GATEACRE
& BELLE VALE

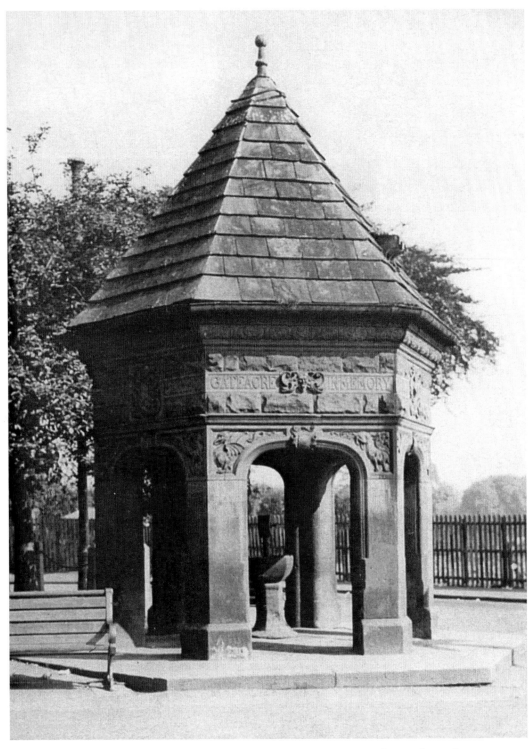

The Wilson Memorial Fountain. Erected by the people of Gateacre in 1883, this sandstone fountain, which stands at the heart of Gateacre, is a symbolic and enduring reminder of the village's past.

BRITAIN IN OLD PHOTOGRAPHS

GATEACRE & BELLE VALE

BERYL PLENT & MIKE CHITTY

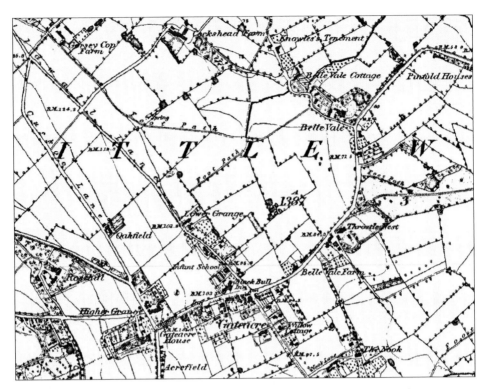

This is an extract from the Ordnance Survey six-inch map of 1850, showing the Gateacre and Belle Vale area in the days when it was almost wholly rural. Some of the buildings indicated on the map still survive. Others have disappeared, but are the subject of photographs in this book.

First published 2009

The History Press
The Mill, Brimscombe Port
Stroud, Gloucestershire, GL5 2QG
www.thehistorypress.co.uk

Reprinted 2010, 2011

ISBN 978 0 7524 5069 8

Typesetting and origination by The History Press
Printed and bound in Great Britain by
Marston Book Services Limited, Didcot

CONTENTS

ACKNOWLEDGEMENTS

We would like to thank all the members of the Gateacre Society, particularly the past and present officers and committee members, without whom this publication would not have been possible. Most of the images have been drawn from the society's extensive collection of local photographs, the assembly of which was largely the work of the late Mrs Sylvia Lewis. Her local history research, and that of other dedicated society members, has given the society archive material which documents the lives of generations of Little Wooltonians.

Thanks are also due to the following, who have contributed photographs or information and helped in numerous ways: Mr and Mrs T. Bailey, Ms D. Barrow, Mr R. Barrow, Mr W. Blundell, Mrs E. Bond, Ms J. Borrowscale, Mr R. Brown, Mr D. Buckley, Mr T. Canty, Mrs J. Clephan, Mr A. Cope, Mr K. Colligan, Mrs S. Davis, Mr J. Dawson, Mrs J. Downey, Mr P. and Mrs J. Fearns, Sir Peter and Lady Forwood, Mrs J. Gadd, Miss J. Gnosspelius, Mr J. Guy, Mr N. Hampshire, Mrs B. Hanssen, Mr R. Harding, Mr and Mrs A. Hutchinson, Mr E. Keen, Mr G. Keen, Ms D. Lee, Mr H. Ledson, Mrs A. Mason, Mr G. Mason, Mrs T. May, Ms B. McKenzie, Mr R. Mills, Ms L. Mitchell, Mrs J. Molyneux, Mr R. Myring, Mrs K. Orlans, Mr J. Platt, Mrs V. Ridley, Mrs S. Peden, Mr and Mrs D. Phythian, Mr W. Pritchard, Ms R.Riding, Revd J. Roberts and Revd D. Roberts, Mr E. Rothwell, Ms S. Sandland, Mr H. Stott, Mrs E. Thomas, Ms J. Thomas, Mrs P. Webb, Mr P. Wilkinson, Mr A. Wood, Mr L. Woodhouse, Dr R. and Mrs B. Yorke. Also the late Miss G. Blundell, Mr P. Bushell, Mr C. Harding, Mr H. S. Davenport, Mr F. Ledson, Mr J.A. Peden, Mr S. Prescott, Mr L. and Mrs G. Shepherd, and Mr W. Wright. We apologise to anyone who has inadvertently been omitted from the above list.

We are particularly indebted to Mrs J. Fearns (*née* Pinnington) for allowing us to use so many of her family photographs. Several of the images (individually credited) are reproduced with the permission of the Liverpool Libraries and Record Office. The Lower Lee and Revd William Shepherd images are from the collection of the National Museums Liverpool (Walker Art Gallery). The Strawberry Field image is included courtesy of the Salvation Army International Heritage Centre. The equipment used to convert the Gateacre Society's photographic collection to digital format, ready for display and publication, was funded by the National Lottery through Awards for All.

INTRODUCTION

Where do Gateacre and Belle Vale begin and end? Once separated by green fields, they now lie cheek by jowl on the southern fringes of Liverpool. Before 1913 they were outside the city boundary, in the districts known as Little Woolton and Much Woolton. The hamlet of Belle Vale was in the township of Little Woolton, as was most of the village of Gateacre, although approximately one quarter was over the border in Much Woolton. The two Wooltons had precise boundary lines, being historic townships of Childwall parish in the hundred of West Derby, within the county of Lancashire. Other neighbouring townships were Childwall, Halewood, Allerton and Wavertree.

Little Woolton's history as a settlement stretches back over 1,000 years. Once wild and wooded, with mosses preventing cultivation, it became after clearance a desirable dwelling place. People settled along the ancient packhorse routes which criss-crossed the township. Starting as a cluster of buildings at the central crossroads, Gateacre grew to a country village, which by 1879 was big enough to warrant its own railway station. The name comes from two words 'gate' and 'acre'. They described the uphill route from the village crossroads to the 'acre field' of Much Woolton and the common grazing land on Woolton heath. From 1867 onwards, the township was administered by the Little Woolton Local Board: a committee of nine local residents.

Gone are the farms and fields, the dairy and the blacksmith, but some aspects of the old-fashioned village remain. They include the chapel, which dates from 1700, three public houses of ancient origin, the village green and adjacent cobbles, a memorial fountain of 1883 and the Queen Victoria monument of 1887. The Gateacre Village Conservation Area, established in 1969, has over seventy listed buildings. Some feature the distinctive local red sandstone, others the attractive black-and-white mock Tudor façades introduced by Sir Andrew Barclay Walker in the late nineteenth century. When the city boundary was extended in 1913, Much and Little Woolton were no more and both Gateacre and Belle Vale became suburbs of South Liverpool.

THE GATEACRE SOCIETY

Trees cut down on Gateacre Brow in the 1960s led to the introduction of the first Tree Preservation Order in Liverpool. Gateacre village was then given conservation area status by Liverpool City Council in 1969. The rapid spread of development in Gateacre at that time alerted local residents to the threat posed to the area and its surroundings. At the suggestion of the then planning officer of Liverpool, Mr Amos, they got together to form the Gateacre Society, to help protect and conserve the old village. The first public meeting was held on 23 October 1974. Over thirty years later the society continues to uphold that aim, encouraging pride in the community and stimulating interest in the preservation, development and improvement of the area. A charity, registered with the Civic Trust, it is involved in local planning, environmental issues, local history and community projects as well as holding exhibitions, talks by invited speakers and walks. The society's Newsletter goes out to over 200 members; much of its content also appears on the website: www.gatsoc.org.uk

Since 1998 the Gateacre Society's members have participated as often as possible in the annual Heritage Open Days held in September, when public and private buildings of interest are open to all. In 2008, Liverpool's year as European Capital of Culture, the installation of a heritage lectern on the village green, giving information on the historic buildings around the village centre, was made possible with a grant from the National Lottery through Awards for All.

While some indication of past times is gained by looking at the older buildings and reading their history, only in the images captured by the camera is that history brought to life. This photographic collection has been put together by the Gateacre Society to serve as a record of the place and its people. Anyone, near or far, with an interest in Gateacre is welcome to become a member.

1

AT THE CROSSROADS

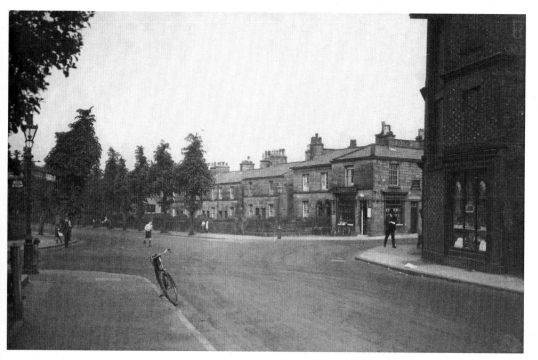

Gateacre, where four roads meet, 1920s. When this photograph was taken there were no road signs (except for the bus stop on the left), no pedestrian crossings, no traffic lights and, apart from a couple of bicycles, absolutely no traffic! The lettering high on the wall of the corner shop on the right, No. 44 Gateacre Brow, reads, 'R. TUSON GROCER'.

The heart of Gateacre lay at a point where four ancient highways met. From its origins as a tiny eighteenth-century settlement around a crossroads, it grew to become a typical rural Victorian village. It attracted wealthy merchants and many a fine nineteenth-century mansion came to be built in the districts of 'Much' and 'Little' Woolton. On one corner of the crossroads is the village green with a stone memorial fountain, erected by the people of Gateacre in 1883, which has become both a landmark and – as the Gateacre Society's logo – a symbol of the village's heritage.

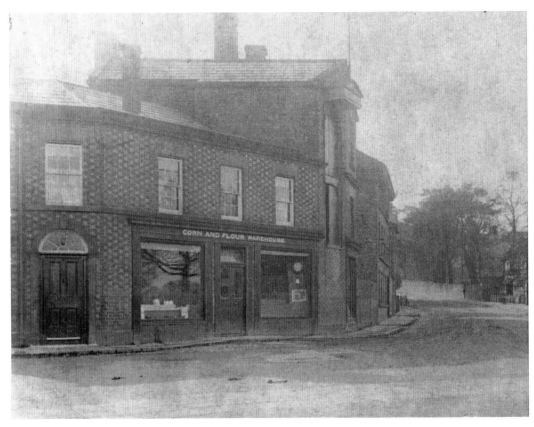

A corn and flour dealer's shop, which was originally a block of cottages built before 1835 on the corner of Gateacre Brow. A three-storey warehouse at the rear had a hoist for lifting goods from carts to the loft. The top storey was removed in the 1950s and the old building, now a music shop, is well maintained by the present owner, Mr Moran.

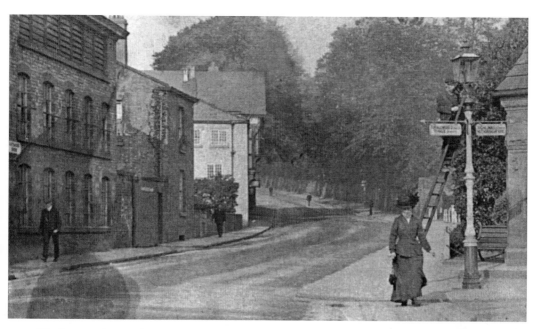

The 'gate to the acre' curving uphill with, on the left, the brewery and brewery house at No. 42 Gateacre Brow. A line of setts on the left-hand side of the brow gave horses a better footing on the incline. The 'NO THOROUGHFARE' road sign which points to Grange Lane and Childwall dates the photograph to around 1914, after Lord Salisbury had erected gates on the lane.

In this photograph the Black Bull public house is obscured by pine trees, which were felled in the 1960s. Just discernible on the driveway behind the trees is an open-top, three-litre Bentley. The sign on the brewery wall, just visible to the left, reads, 'Please slacken bearing rein before ascending the hill.'

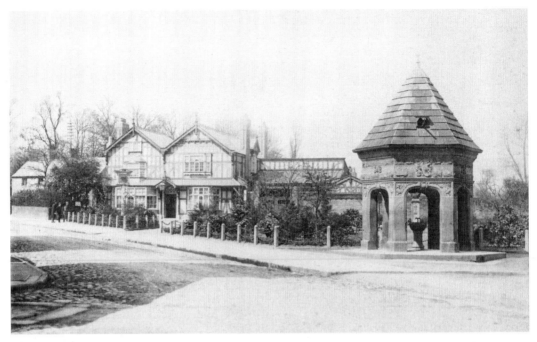

This view from the crossroads, taken between 1887 and 1891, shows a telegraph pole in the garden of No. 1 Gateacre Brow, where the first sub-telephone exchange was installed at the post office. This was before the four cottages on the left were altered to three and given new black-and-white frontages.

A tiny snapshot from 1949 shows us the aptly named Thornside Farm on Grange Lane. It was built, probably before 1700, in the field on the corner called Thistly or Thorny Croft, where the present-day Conservative Club now stands.

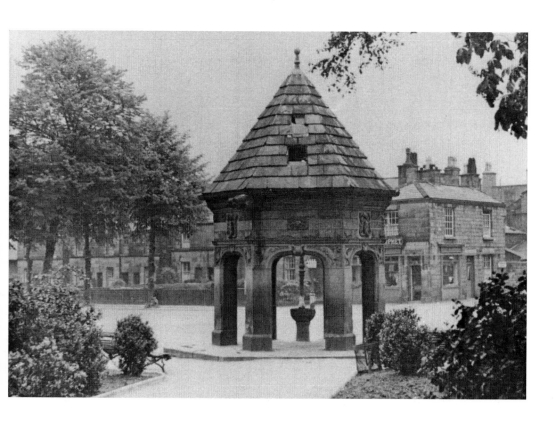

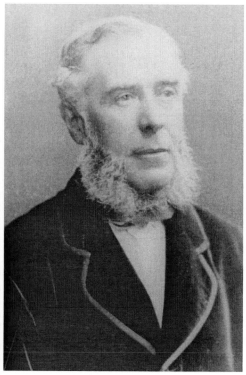

Above: The inscription on the memorial fountain reads, 'ERECTED BY THE PEOPLE OF GATEACRE IN MEMORY OF JOHN H. WILSON 1883.' John Hays Wilson, a brassfounder with business premises in Liverpool, had lived at Lee Hall in Gateacre and had been a member of the Liverpool Town Council as well as chairman of the Little Woolton Local Board.

Left: John Hays Wilson, who died in 1881 after catching a chill at the Tarbock Races, which were held that year in the grounds of Lee Hall. At the time of his death, Wilson was chairman of the Liverpool Water Committee, engaged in the scheme to bring much-needed water to the city from Lake Vyrnwy in North Wales. The water supply into the basin was capped over fifty years ago and health and safety regulations prevent it being restored. (Courtesy of Liverpool Record Office, Liverpool Libraries).

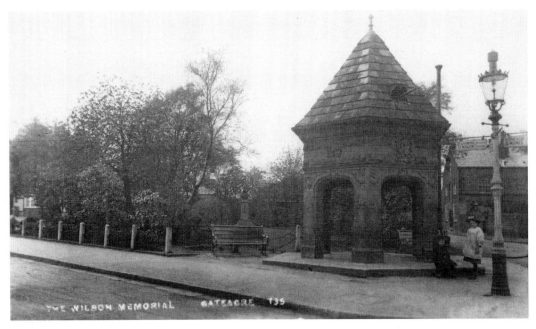

The village green was a place to play or sit and pass the time of day, when Grange Lane was just a leafy lane through farmland and only horse-drawn traffic traversed the crossroads.

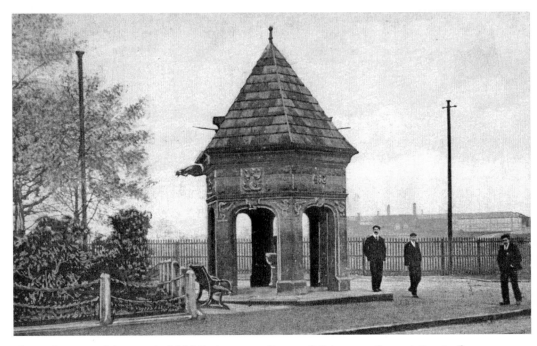

This early postcard (postmarked 1906) gives us a glimpse of Gateacre railway station in the distance. The tall pole on the left is not a flagpole but a vent from the sewer under Grange Lane. The provision of sewerage within the township was one of the main functions of the Little Woolton Local Board, its full title being the Local Board of Health.

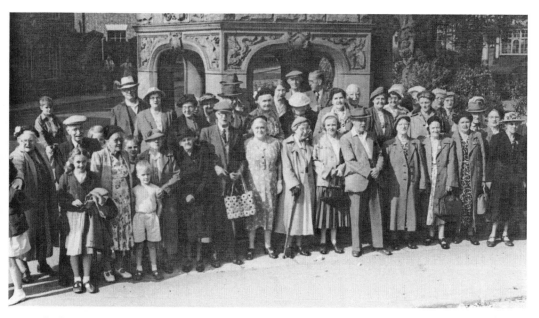

The hexagonal drinking fountain, of decoratively carved red sandstone, serves as a meeting place for talks, walks and events. This was a pensioners' group outing in August 1955 and somewhere on the photograph is Mr John Phythian. The roof of the monument served as a dovecote and the gargoyle hid a drainpipe.

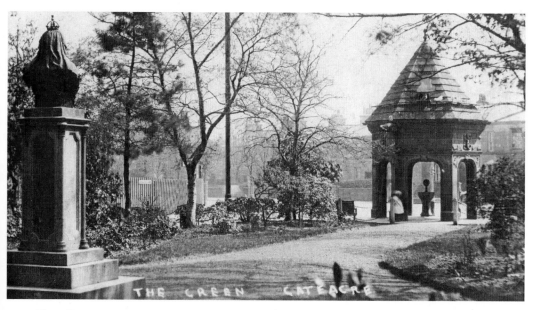

The village green was given to the people of Gateacre in 1887 by Sir Andrew Barclay Walker of Gateacre Grange, to celebrate Queen Victoria's golden jubilee. Its centrepiece was a bronze bust of Her Majesty, sculpted by her nephew Count Gleichen. This postcard was sent to a patient at the New Brighton Convalescent Home in 1905. The neat shrubberies of Edwardian times have now gone, but today the village takes part in the annual North West in Bloom competition, displaying tubs and baskets of seasonal plants provided by the Friends of Gateacre.

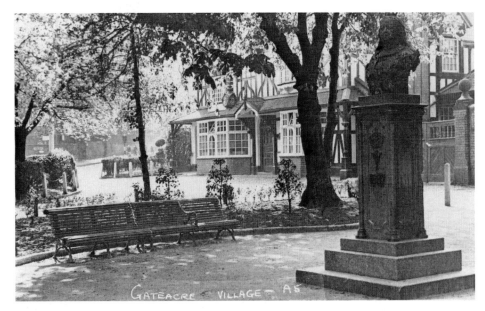

Her Majesty surveys her surroundings with the 'we are not amused' expression captured in bronze by her nephew. A number of memorial trees have been planted on the village green in recent years to commemorate certain people or events.

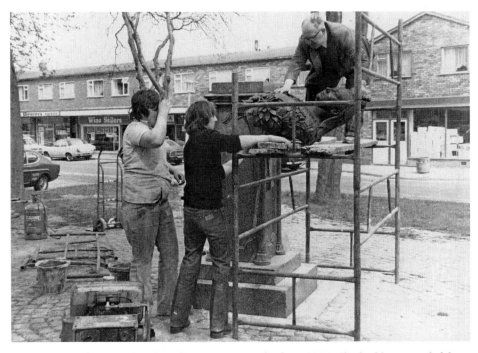

Queen Victoria being replaced on the rose-granite plinth in 1980. She had been toppled from her pedestal by over-enthusiastic football fans in 1978, rescued, and restored at the Liverpool Museum. The process involved bombarding the bronze with walnut shells which, at the time, was the most effective way of dislodging the verdigris without damaging the metal.

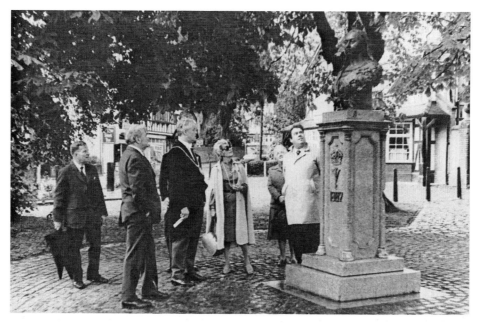

A tour of inspection by Alderman James Ross (Lord Mayor of Liverpool), Mrs Elizabeth Scarland (Civic Trust for the North West), Revd Daphne Roberts (Minister of Gateacre Chapel), and Mr Tony McCann (Chairman of the Gateacre Society), 7 October 1980.

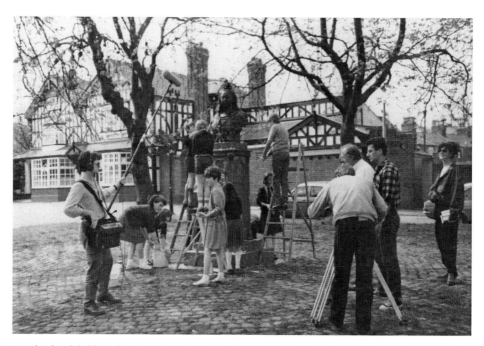

Local schoolchildren being filmed for Granada Television giving Queen Victoria her annual spring-clean during Environment Week, April 1985. More recently, both the Gateacre Society and the Friends of Gateacre have been assisted in 'clean ups' by pupils from Gateacre Comprehensive School.

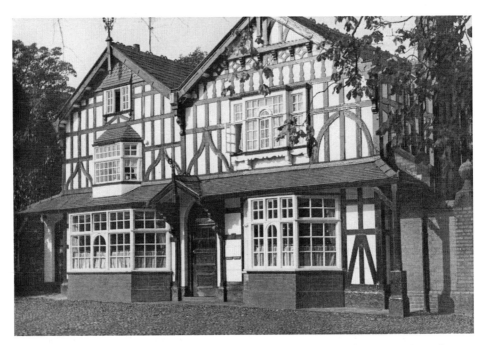

In 1753 a licence was granted to David Edwardson by the West Derby Manor Court for him to sell ale from his house in Little Woolton. It quickly became known as the Bull, then the Black Bull. None of the fabric of the old house remains, as it suffered a fire in January 1881. It was rebuilt by A.B. Walker, who, having just built the mock-Tudor Church Cottages in Belle Vale Road, now introduced the style into Gateacre village centre by giving the new Black Bull the black-and-white decoration we see today.

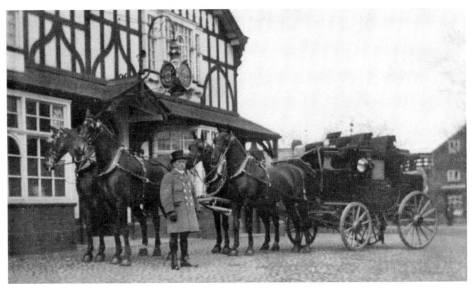

A mystery snapshot of a coach and four outside the Black Bull. Was this the type of coach that collected distinguished guests from the railway station? Of interest is the detail of the Warrington Ales lantern which hung above the entrance to the inn.

Crossing the cobbled courtyard outside the Black Bull, members of the Liverpool
Pickwickian Society capture the spirit of Victorian times in December 1938. (Courtesy of
Liverpool Record Office, Liverpool Libraries)

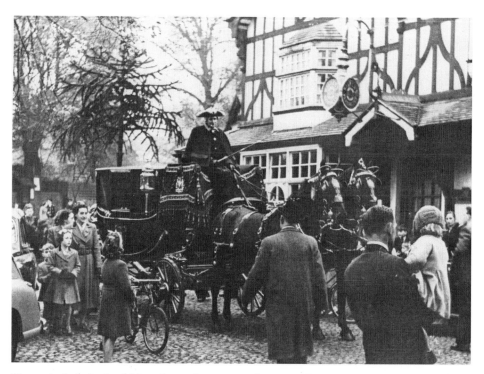

The arrival of the Lord Mayor's coach attracts admiring villagers on 22 October 1951.
The visit, by Alderman Vere Cotton and the Lady Mayoress, was to honour the 250th
anniversary of Gateacre Chapel.

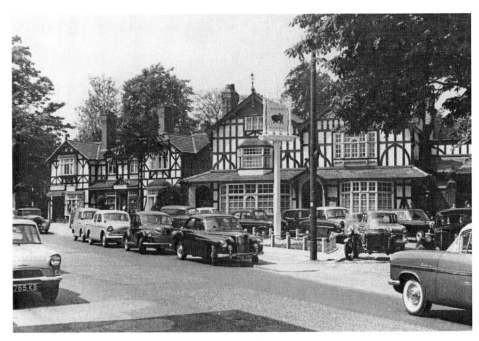

Motor enthusiasts will be able to date this photograph from the vehicles outside the Black Bull public house, in the days when there were no parking restrictions or double yellow lines.

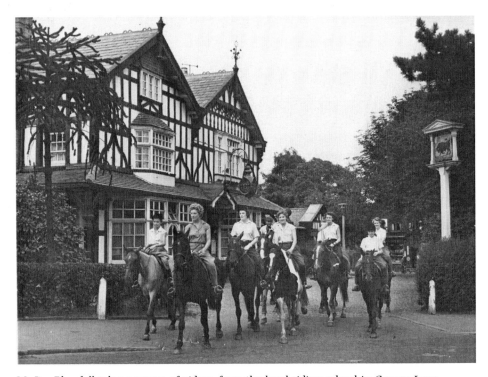

Mr Jim Blundell takes a group of riders, from the local riding school in Grange Lane, through the village in 1955.

2

GATEACRE BROW

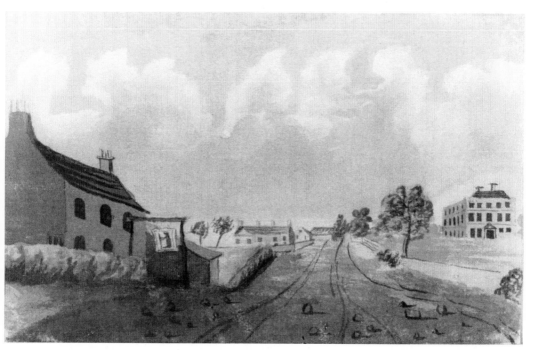

A drawing from around 1815 showing, on the left, the Bear and Ragged Staff pub sign. On the right is a house called Higher Grange at the top of the Brow. In the 1820s this became a girls' boarding school, or 'academy', run by Miss Sarah Lawrence. It was still a boarding school, for young ladies age ten to nineteen years, at the time of the 1861 Census. (Courtesy of Liverpool Record Office, Liverpool Libraries, ref. Binns collection vol.12 p.19 Neg.1 H/6 1976).

The track uphill from the crossroads was the gate (or way) to the acre field of Much Woolton – hence the origins of the name Gateacre. In old documents it was often spelt as two words but at some point the pronunciation changed to the present 'gataca'. In 1868 the road was named Gateacre Brow by the Little Woolton Local Board. The township boundary also followed this uphill path, which meant that all the property on the Gateacre Chapel side lay in Much Woolton. The view from the crossroads remains one of the least altered in any of the Liverpool conservation areas.

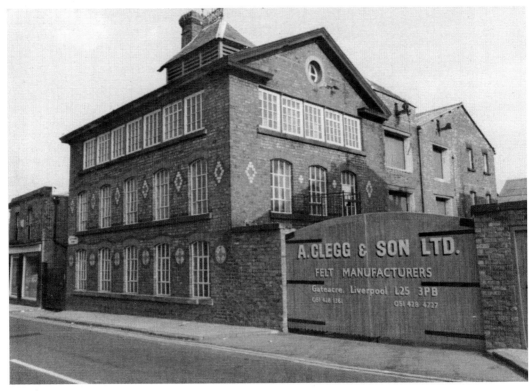

This Victorian brewery building, with patterned brickwork and decorative weathervane, probably dates from the 1860s. It was converted to Messrs A. Clegg & Son's flock and felt factory in the 1930s. A previous brewery on the same site was owned by the Fleetwoods, maltsters of Tarbock. John and Thomas Gregory took over the Gateacre brewery from the Fleetwoods in 1877. The house across the courtyard, No. 42, was the master brewer's residence. Cleggs' factory closed in 2003 and, at the time of writing, the complex of buildings is being converted to residential apartments.

Right: The Gregory brothers previously owned a
brewery at Mersey Road, Aigburth. Living in the
brewery house on Gateacre Brow in 1881 were
John Gregory, his wife and five children. From 1907,
William H. Gregory was resident at No. 42, and
the brewery was in the hands of Thomas Gregory's
executors from 1910 to 1920. This 1916 photograph
shows a member of the Gregory family in First World
War uniform.

Below: Photographed outside No. 28 Gateacre Brow
are saddler Robert Riding and his wife Sarah, *c.*
1898. The building, which dates from before 1835,
was then three storeys high. Robert had been saddler
for the previous owners, John and Mary Westwick.
The shop next door, also owned by the Westwicks,
was pulled down in 1888 to make way for the new
telephone exchange.

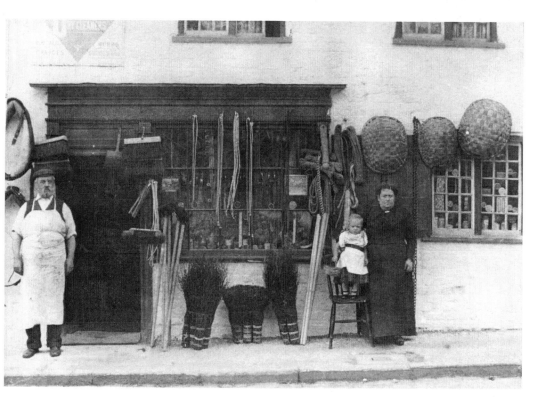

Left: A fashionable 1940s portrait of Joan Molyneux (*née* Rothwell), the hairdresser at No. 28 Gateacre Brow in the 1960s and '70s. Previously the shop had been a greengrocer's and fishmonger's run by Mrs Eva Hitchens.

Below: The Marsh brothers moved their grocery business from No. 10 Gateacre Brow to the new double-fronted shop at No. 28A in 1891. Living above the shop in 1911, with seven daughters and three sons aged between one and twenty, were grocer's assistant Mr Patrick Burke and his wife Clara.

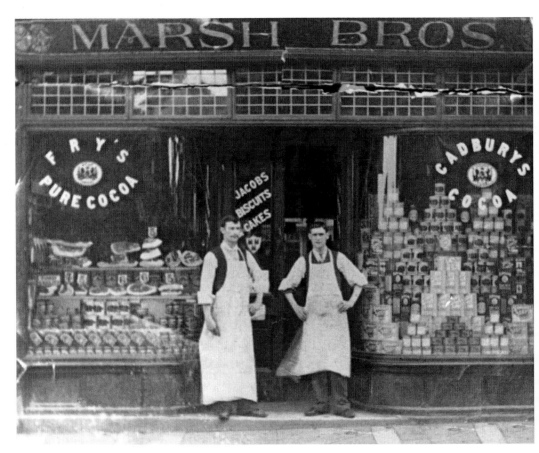

On the corner of Sandfield Road stands the prettiest of Gateacre's listed buildings, with its distinctive black-and-white timberwork and a corner turret with oriel window. It was built for Mr George Hunter Robertson, a cotton broker living at The Laurels in Nook Lane, off Halewood Road. He was instrumental in the setting up of one of the first telephone companies in Liverpool and commissioned the young architect, Walter Aubrey Thomas, to build a new sub-telephone exchange in Gateacre, in keeping with the decorative style introduced to the village by Sir A.B. Walker in the 1880s. The result in 1891 was the building now known as 28ABCD Gateacre Brow, which had two shops

on the ground floor with the telephone exchange and living accommodation above. It is said that Thomas took his inspiration from buildings recently erected in the centre of Chester and that the plaster-relief panels of biblical scenes were copied from Flemish originals. In 1902, the tiny corner shop opened as a branch of Parr's Bank (later Westminster Bank), then in 1947 it became a branch office of the Prudential Assurance Co. The same architect designed Liverpool's iconic Royal Liver Building, built 1908–10.

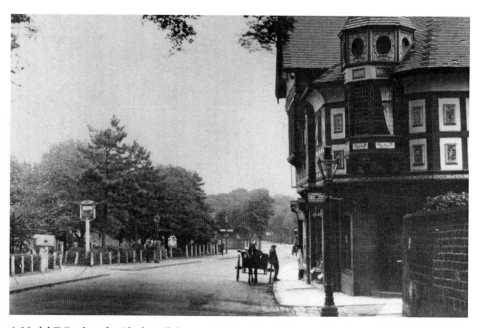

A Model-T Ford in the Black Bull forecourt dates this photograph to around 1920. Sandfield Road, which branches off Gateacre Brow between the chapel and 28ABCD, was created in 1835 and led to an area of ground known as the 'sandhole', from where building sand was extracted.

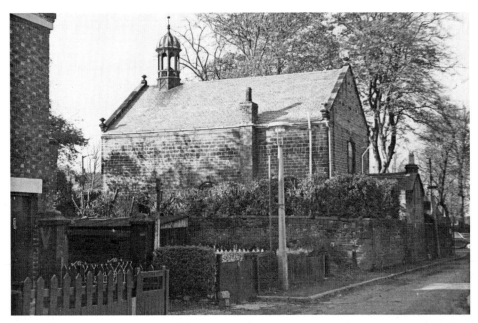

Gateacre Unitarian Chapel, viewed here from Sandfield Road, bears a datestone of 1700. It was built for Protestant dissenters from the Church of England, who established an English Presbyterian congregation known as Little Lee Chapel in Gateacre in 1690. A country chapel around which the village grew, it was the centre of intellectual, social and religious life. By the nineteenth century the chapel had become Unitarian, and among its members was Henry Tate, the sugar refiner who lived in Woolton Park. In 1872 he presented the Good Samaritan stained-glass window at the east end.

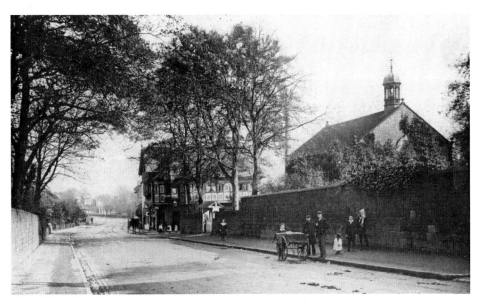

A Victorian postcard of the ancient chapel by Brown, Barnes and Bell, Royal Studios, at No. 31 Bold Street, Liverpool. Recent restoration to the cupola means the bell, which bears a date of 1723 and the inscription 'Come away make no delay', can now be rung again.

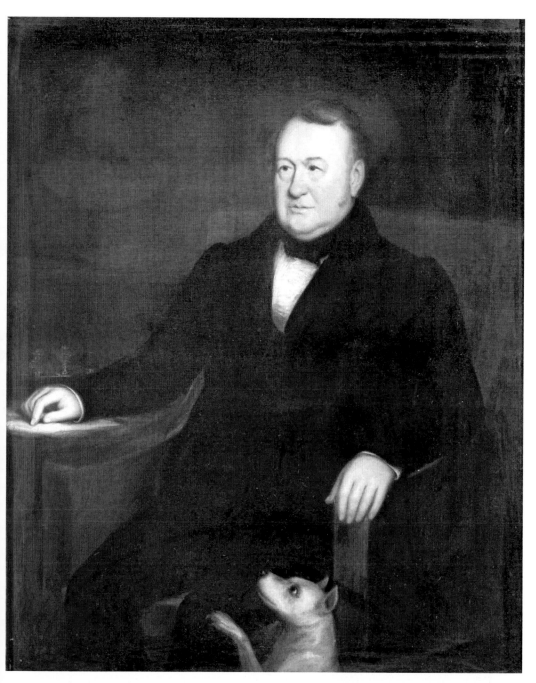

An early nineteenth-century portrait of Oxford scholar and literary friend of William Roscoe, the Revd William Shepherd LL.D., painted by Cornelius Henderson. As well as being master of a successful boys' school at The Nook, off Halewood Road, he was Gateacre Chapel minister from 1791 for fifty-six years, during which time its Unitarianism was strengthened. Dr Shepherd died in 1847, but his marble bust and memorial tablet can still be seen in the chapel.

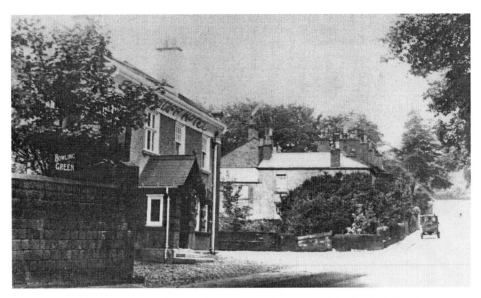

Above: One of the earliest hostelries in Gateacre was the Bear and Staff, which has been altered and extended many times. It was originally called the Bear and Ragged Staff (1798), then the Bear Inn (1806). It is seen here with an Art Nouveau style façade of the 1920s. Despite objections, a car park was built on the bowling green in 1984 and the stables became new dining rooms. The bear and ragged staff was the emblem of the Earls of Warwick, but there is no evidence of a local connection. It seems likely that it was adopted as an easily-recognised symbol in the days when few people were able to read the names of inns.

Opposite below: Miss Annie Wyke from York Cottages (second from the right) was a maid at the Bear and Staff. On the left are Sam McCredie, a jockey, and Mr Ogden, a gardener.

Right: A portrait photograph of Winifred and Doris Wyke, younger sisters of Annie, 1901. Doris (on the left) is well remembered at Gateacre Chapel, where she was secretary for nearly forty years.

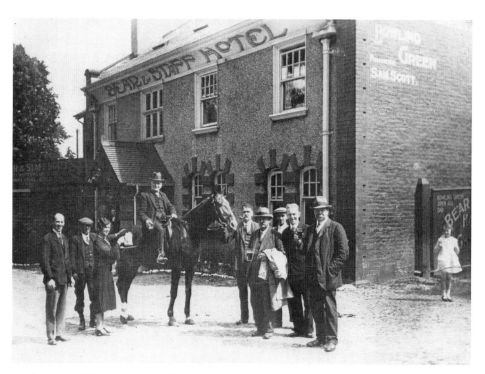

Mr Sam Scott (the Bear and Staff landlord) is seen here on the far left with his wife, *c.* 1930. His daughter, Irene, can be seen on the far right, while Mr William Turton is on horseback.

This photograph of No. 10 Gateacre Brow was taken when it was Dawson's newsagents, 1985. The early Victorian shop front survives, but the white-painted scored stucco shown here was removed from the stonework during renovation in 1989. Behind No. 10 are Nos 12 and 14, now one dwelling but previously two of a group of seven known as Bear Cottages. The other five were removed before 1920.

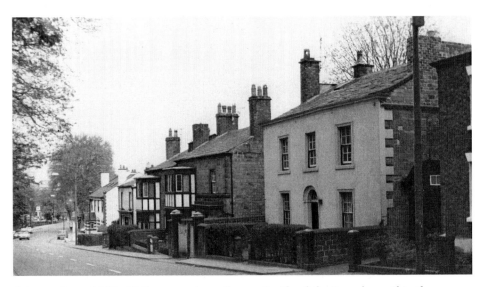

Gateacre Brow, 1977. All the property on the south side of the Brow lay within the township of Much Woolton. In 1878, Revd George Beaumont of Gateacre Chapel bought Nos 4, 6 and 8 with the proceeds from the sale of The Nook to the railway company. Named Chapelstead, No. 8 remained the chapel ministers' residence until 1961. The advice of English Heritage was sought when extensive restoration work was undertaken at No. 4 – Browside – in 1989. After the removal of stucco, damaged stonework was repaired and the house was lovingly refurbished as semi-detached dwellings No. 4 and No. 4a; a successful outcome for a listed building within the conservation area.

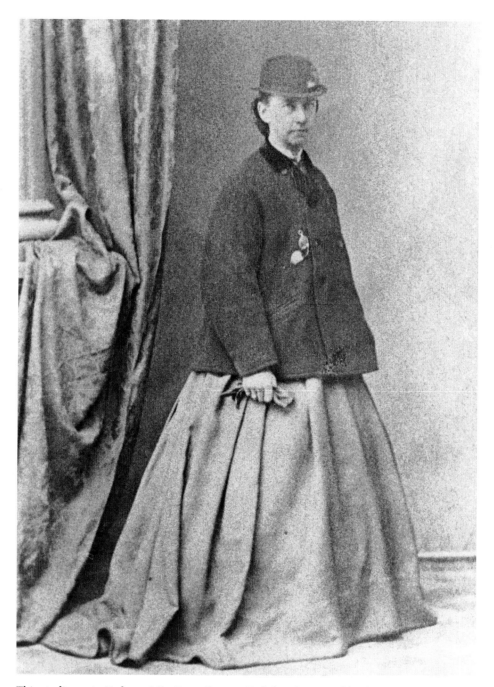

This studio portrait shows Miss Janet Preston Rodick, who owned land and property in Much and Little Woolton. Her father, Thomas Rodick (1789–1855), was a Liverpool merchant and JP who had built No. 4 Gateacre Brow as Kendal Cottage around 1814. Mr Rodick owned land from the top of the Brow down to the sandhole and had his stable block (now Dale Mews) and two cottages built, away from the house, on Sandfield Road. The family were Unitarians and there is a memorial tablet to them in Gateacre Chapel, where Thomas was warden for seven years.

Originally four plain cottages, Nos 3, 5 and 7 Gateacre Brow had black-and-white frontages, with Arts and Crafts decoration, added by Sir A.B. Walker in the 1890s. After being demobbed from the Army in 1946, Mr Kenneth Orlans opened his chemist shop at No. 5, followed by Mr Prendergast in the 1950s. Before the war, Mr J. Scott had been the chemist and Mrs Scott the postmistress next door.

Dates of photographs can often be judged by the size of the monkey puzzle tree in the garden of Lynton, No. 7 Gateacre Brow. The high sandstone wall on the north side of the Brow bordered the grounds of Gateacre Grange.

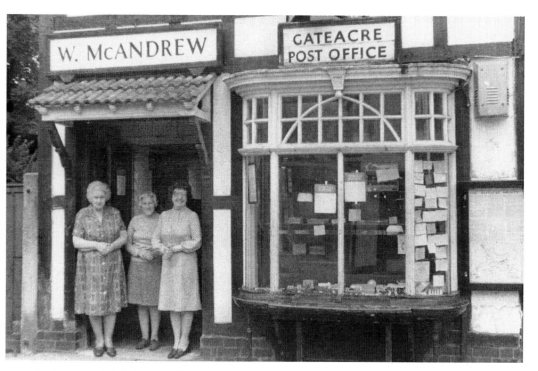

At the door of the old post office, on the day of its closure in 1978, are Winnie McAndrew, Evelyn Dykin and Claire Crinnon. Miss McAndrew had been postmistress for thirty-six years. The post office building became Garfield's jewellers shop, and is today a private house.

A view of the Brow in the 1930s, which remains much the same today. Soon after James Marsh had retired, in 1919, the grocer's became Brooks & Co. Ltd with the same manager, Mr Charles Wright. Then, in the 1970s, it became Harriett Stein's dress shop.

An early photograph of Lower Sandfield cottages, built around 1840 in the former sand pit – the 'delph' – off Sandfield Road. Although Nos 5-7 and 9-11 are still there today, Nos 1-3 were demolished around 1968. In the background is the Church of England school on Halewood Road.

From small beginnings Rimmer's timber yard, in Sandfield Road, grew to today's Travis Perkins. In 1946 it was called the East Liverpool Mortar Mills Ltd. The next owner of the builders' merchant business was Mr Tommy Jones; then in 1961 it became Wm Turner & Co. Our picture is dated 1979, when the yard was owned by Mr Rees-Jones.

3

GRANGE LANE

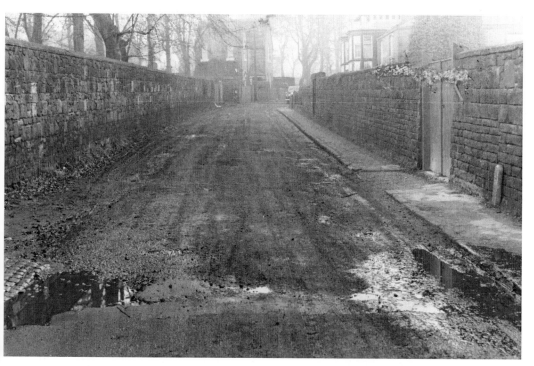

Grange Lane today is a busy thoroughfare. Newcomers find it difficult to believe that, until the late 1950s, it was still an unpaved, muddy track. This photograph, showing the view from outside Soarer Cottages, was taken by the City Engineer's Department in November 1954. Rockfield Lodge and Lower Grange can be seen in the distance and on the left is the Gateacre Grange boundary wall, through which Gateacre Rise was later cut. The argument over whether this part of Grange Lane was a private road had persisted for decades. The matter was decided at a court hearing in 1955. It was ruled that Grange Lane was, and always would be, a public highway, and therefore the council was responsible for the upkeep. By 1965 it had been made good. (Courtesy of Liverpool Record Office, Liverpool Libraries, ref. 14602)

Grange Lane was previously a continuation of Childwall Lane, connecting the parish church at Childwall with the village of Gateacre at the crossroads. It was a public highway and the traditional funeral route to the ancient church but, twice in its history, access was denied when wealthy landowners closed it with gates. It remained a narrow country lane until phase one of Gateacre Comprehensive School opened in 1958. The school's official opening was in 1962 and afterwards, to accommodate the ever increasing traffic, the lane was twice widened at the southern end.

The Lodge on the corner of the present-day Gateacre Park Drive was a police station for a short period from around 1903 to 1910. Grange Lane was twice closed to traffic by the Lord of the Manor – firstly by Isaac Greene in the eighteenth century and again by Lord Salisbury in the early twentieth century – but there was a small gate beside the lodge which gave pedestrian access to the lane. Coachman Edward Robinson was the lodgekeeper from around 1876 until 1889.

Right: After managing the Childwall Gas Co. for Lord Salisbury for over forty years, Mr George Harding retired to The Lodge in 1911. The company supplied gas from its Rocky Lane works in Broadgreen, not only to Lord Salisbury's residence at Childwall Hall but also to private homes, including the large mansion house at the northern end of Grange Lane called Gorsey Cop.

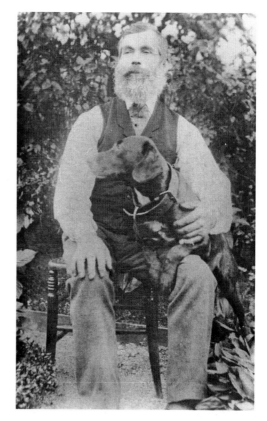

Below: This attractive Italianate villa of the 1860s – Grange Hollies – was the home of Liverpool brewer William Theodore Bent. His effects when he died in 1890 were valued at £38,945 3s 8d. The house name can still be seen on the tall sandstone gate piers. Slightly extended, it is now an Abbeyfield retirement care home.

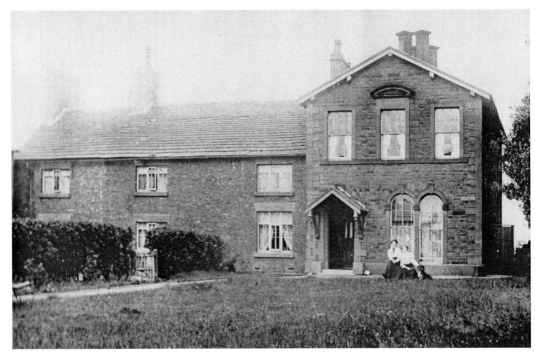

Nestling in the vale beneath the bluff of a sandstone ridge was this pretty farmhouse, Gorsey Cop Farm, which had at one time been owned by Childwall Church. Henry Hulme was the farmer of 160 acres in 1881, with five men and two boys. The Ledson family were the farmers in 1919.

Mr Ledson is pictured here in the farmyard preparing for an outing in his pony and trap.

A moment of relaxation for the farmer and his wife, Mr and Mrs George Ledson. The three farms in the fertile valley were Gorsey Cop, Cockshead and Belle Vale, which were all linked to Grange Lane by public footpaths. The Leybourne and Hathaway Road houses were built on the farm site in the 1960s.

In the farmyard and just taller than the carriage wheels is a young member of the Ledson family.

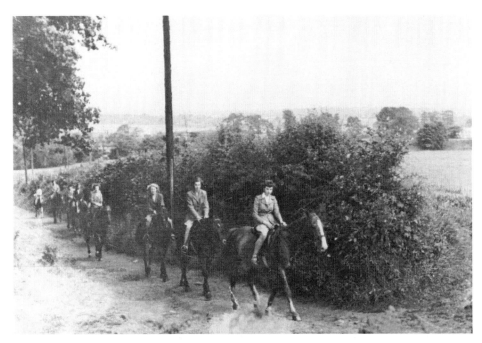

Riders photographed more than fifty years ago on the track which is now Grangemeadow Road. It led from Cockshead Farm to Grange Lane, across what is now the school field to Cuckoo Lane and then uphill to Black Wood. The farm, one of the oldest in Little Woolton, was owned by Mordecai Cockett in the eighteenth century.

At the door of Elm Cottage is Ralph Hindle Baker, born in 1860, who was a warden of Liverpool Cathedral, honorary secretary of the Liverpool Church Choir Association and a committee member of the Liverpool Philharmonic Society. Elm Cottage stood on the west side of Grange Lane, just north of Oakfield Avenue. A previous tenant, Miss Emma Evans, had a girls' day and boarding school here, from around 1861 until the mid-1870s.

The gates installed on Oakfield Avenue and Grange Lane had a lasting effect. The city council reported in 1954 that for 170 yards from the Gateacre Institute to Oakfield Avenue, the lane was not sewered, levelled, paved or lit. This picture, taken by the City Engineer's Department in April 1958, shows the last few yards of the unmade road in the foreground. (Courtesy Liverpool Record Office, Liverpool Libraries, ref. 17925)

This house, which stood on the corner of what became Grange Weint, was originally the lodge to the larger Rockfield on Rose Brow. The photograph is from the late 1960s, as in the early 1970s the front boundary was moved back in line with the gable end. Binkie Brown ran a market garden here during the Second World War and surgeon John McFarland was the occupier in the 1950s.

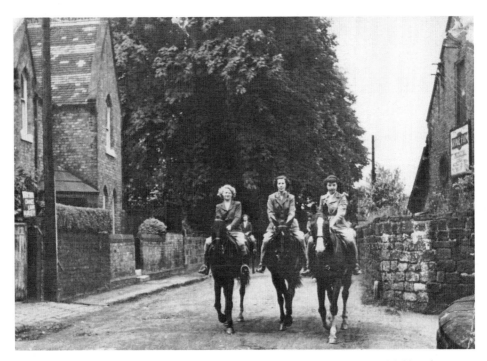

Girls riding 'Velvet', 'Monarch' and 'Bobby' in the 1950s. On the left is Rockfield Lodge and to the right is Lower Grange Farm. Joseph Turton was the farmer in 1841 and 1851, followed in 1861 by John Turton. Charles W. Kellock, ship owner and broker owned the Grange estate from the early 1870s until his death in 1897. From 1910 it was the property of James B. Atherton, electrical manufacturer. The Taylor family were the farmers from 1926 until 1968, by which time most of the land had been sold for housing.

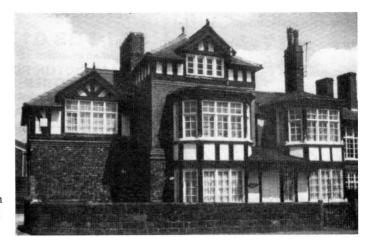

There is mention of a Little Woolton 'grange' in the thirteenth century, when Cistercian monks were farming the land. From around 1558, it was tenanted or owned by members of the Orme family. William Barrow of Halewood bought The Grange in the early 1700s and on his death in 1733 the estate passed to his eldest son, William jnr. Three generations of Barrows owned the Lower Grange Farm (pictured here) and the adjoining house, Grange Lodge, until 1861. William Barrow jnr (1710–1791) was a renowned watchmaker as well as farmer. One of the five major landowners in Little Woolton, his estate stretched from Rose Brow down to Belle Vale.

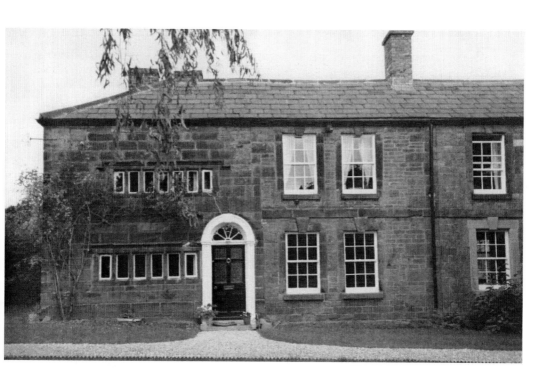

Above: Adjoining the former Lower Grange Farm is Grange Lodge, which was built in three parts. The first and closest to the road was built around 1650, the middle section around 1720 and the last around 1820. Living at Grange Lodge from 1959, for more than thirty years, was Mrs Sylvia Lewis, who was honorary secretary of the Gateacre Society between 1974 and 1986 and who researched the history of the house and its inhabitants.

Right: This is Mrs Mary Niven, widow of Captain Niven, who bought Grange Lodge in 1920. The occupants in the 1950s were the Misses M. and J. Niven and their friend Miss Emeline S. Taylor.

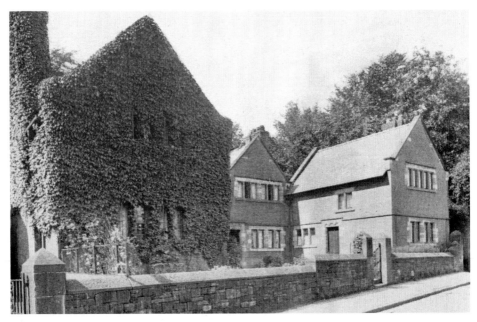

Soarer Cottages were four cottages built in 1896 by William Hall Walker, of Gateacre Grange, for his married grooms. They were named after his horse 'The Soarer', ridden by David Campbell, which won the Grand National that year. This photograph was published in an auction catalogue of 1917, when various Walker-owned properties were sold off. The catalogue describes the cottages as 'constructed regardless of cost'. The architect was Richard Beckett of Hartford, Cheshire.

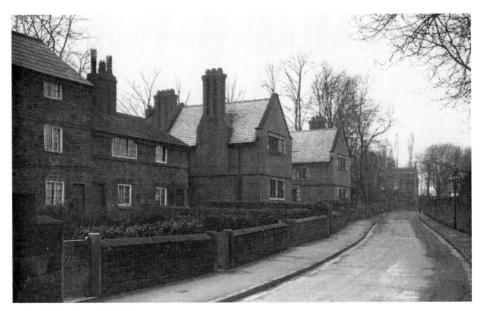

This aspect of Grange Lane, featured in a postcard of the early 1900s, looks much the same today. On the left are the five cottages of Paradise Row, and Soarer Cottages (seen here without the ivy). In the distance is Rockfield Lodge.

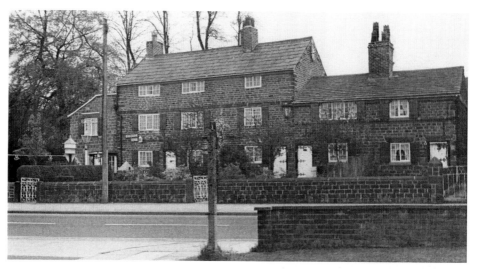

When renovation work was being carried out at Paradise Row in 1983, metal fragments were discovered in the upper rooms of these early to mid-seventeenth century cottages, suggesting that they were used as workrooms for outworkers of the Prescot watchmaking industry. Once part of the estate of watchmaker William Barrow, they may have originally been single-storey and perhaps thatched.

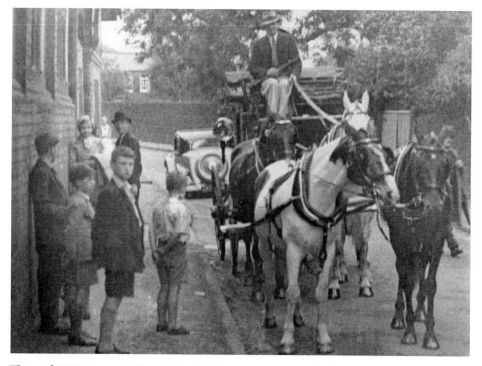

This mid-1930s image tells us that vehicles were traversing the lane as, every Wednesday evening, Mr George Oldfield drove this four in hand along Grange Lane, sounding the horn to advertise the Tatler news cinema in the centre of Liverpool. Two of the boys standing by the stable wall are Gerald Hester and Douglas Wright.

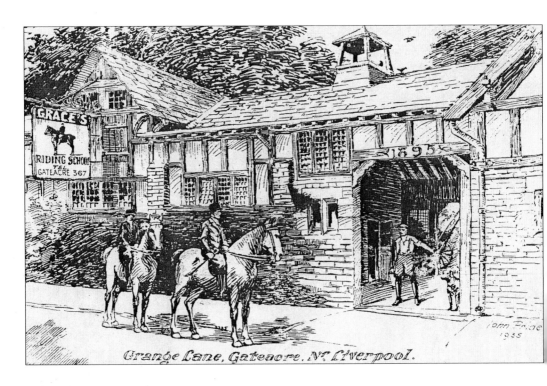

Grange Lane, Gateacre, Nr. Liverpool.

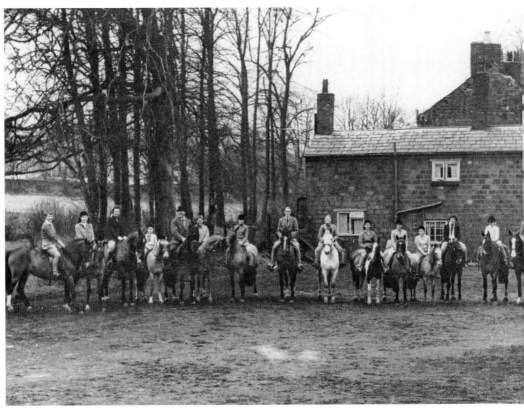

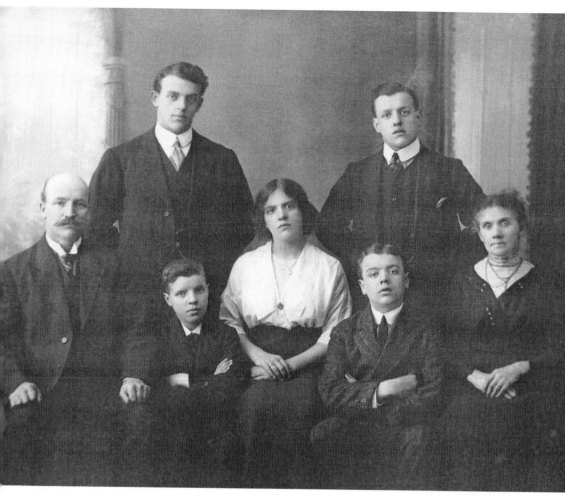

Mr William Pinnington and his family lived in the cottage at the southern end of the stable block until around 1916/17. The eldest son, also called William (top left), was awarded the Distinguished Conduct Medal (DCM) for 'showing the greatest courage and devotion to duty' at Guillemont, France in 1916, whilst serving under Captain Noel Chavasse during the First World War.

Opposite above: The cottage and stable block, built by William Hall Walker in 1895 for his polo ponies, became James Blundell's Riding School in 1935. Riding was a popular pastime in Gateacre until 1980 when the school closed. Increased traffic had made it a hazardous pursuit. (John Pride drawing, 1935, courtesy of Liverpool Record Office, Liverpool Libraries, Neg.19J/7 1978)

Opposite below: A group of riders photographed in the paddock behind the stables with No. 1 Paradise Row in the background. By 1983 the stable block, a listed building, had been successfully transformed to housing grouped around a courtyard and named Grange Mews. At the northern end of the mews is Riding School House, built for Mr and Mrs Blundell in 1968.

Gateacre House stood on the east side of Grange Lane, opposite the stables. Home to Councillor Rupert Bremner and Mrs Annie Bremner, the house and grounds were sold for redevelopment around 1960. The couple were remembered as 'true Edwardians' by the villagers, still living in a style that had long gone.

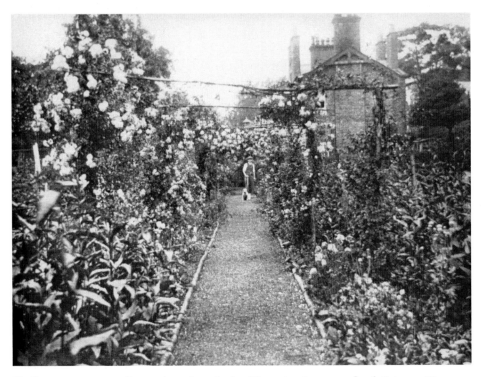

Mr Bremner was a poultry and produce dealer. The extensive grounds of Gateacre House included a poultry farm and, as can be seen here, a rose garden.

Right: Peter Prescott in his role as chauffeur to the Bremner family, 1932. His brother, Harold, was employed as a gardener and poultry man.

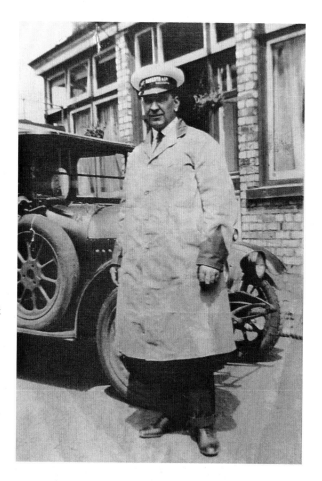

Below: A pre-1895 photograph of Grange Lane taken from the railway embankment. The riding stables are not yet built. The building on the left with a central porch is the Gateacre Institute, opposite the farmyard of Thornside dairy. Behind, with a plume of smoke from the chimney, are York Cottages. Beyond is the Walker estate, Gateacre Grange on Rose Brow. In the foreground, amongst the trees to the right, is Gateacre House and top right is Hillside on Cuckoo Lane.

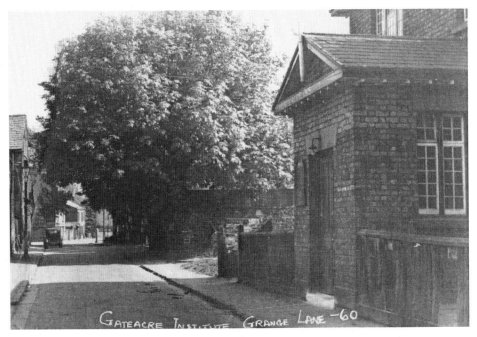

The present-day Gateacre Institute bears a datestone of 1838. As the Little Woolton and Childwall National School, it served the boys and girls of Gateacre for forty years. When the school moved to a new site in Halewood Road, the old building became a library and reading room and in 1887 it was formally presented to the people of Gateacre by Sir A.B. Walker as a recreational centre, and given the name the Gateacre Institution. As a private members' club, it is still in use today.

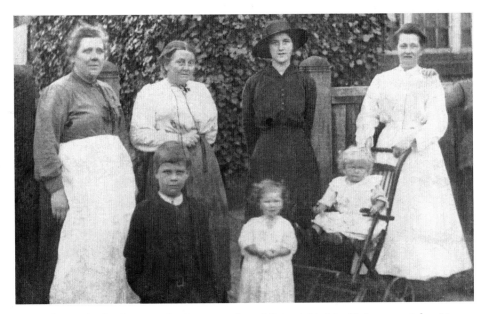

Pictured outside the Gateacre Institute are, from left to right: Mrs Hulme, caretaker Mrs Felton, Mrs Jack Hulme, Mrs E. Wyke of No. 6 York Cottages, and their children.

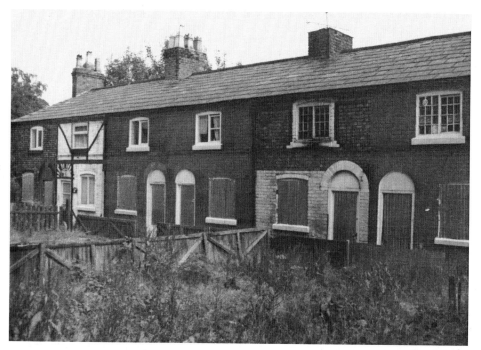

York Cottages, off Grange Lane, consist of two terraces of artisans' cottages built of local brick around 1840 by a Yorkshireman – hence the name. In the early 1970s they were earmarked for demolition under slum clearance powers, but a successful campaign to save them led to complete refurbishment in 1976–78. This photograph shows the cottages as they appeared in August 1976.

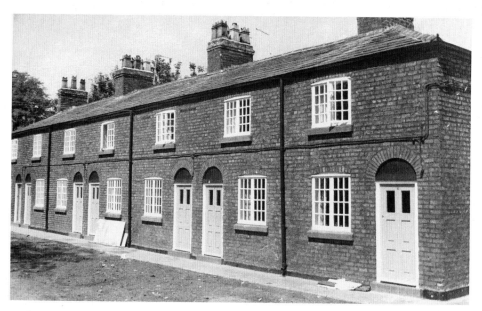

York Cottages are seen here restored to desirable dwellings again, showing that they were well worth saving.

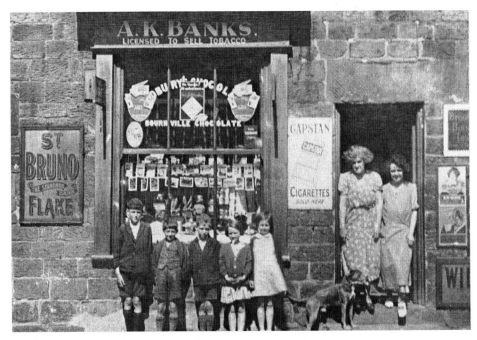

This was the only shop on Grange Lane when this photograph was taken in 1936. It was situated roughly halfway along the present-day shopping parade, immediately opposite the roadway which leads to the Black Bull. Mrs A. Banks is on the step, while the children are, from left to right: Gilbert Hayes, Dougie Wright, Albert Hayes, Kathleen Keen and Peggy Scrambler.

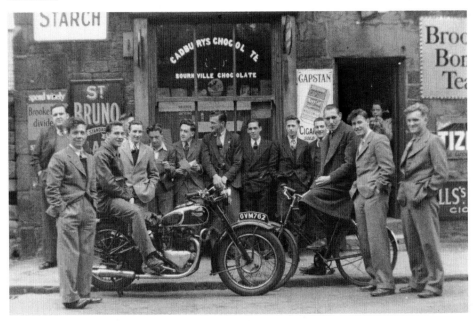

The local lads – the Gang of '49 – met up on a Sunday afternoon outside the village store. From left to right: Stan Prescott, ? McNeill, Ray Crawford, Mick Stevens, -?-, Billy Handley, -?-, ? McNeill, Doug Wright, Les Woodhouse, Albert Hayes, -?-, -?-.

Banks' shop had become Mr Davenport's Grange Lane Stores by the 1950s. In 1964 the shop moved into a purpose-built unit on the new parade a few yards further north, and the old building was then demolished to allow the rest of the shopping parade to be completed. To the left of the shop were two cottages set back from the road, and Thornside farmyard and barn. Arthur Guy ran the dairy, then Mrs Sarah Guy in the 1920s and '30s, followed by Mr and Mrs Jack Taylor.

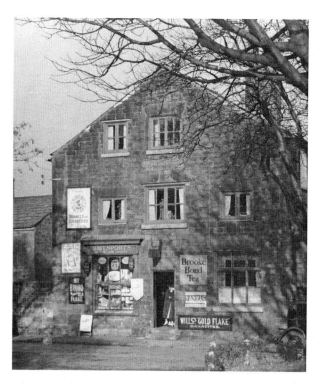

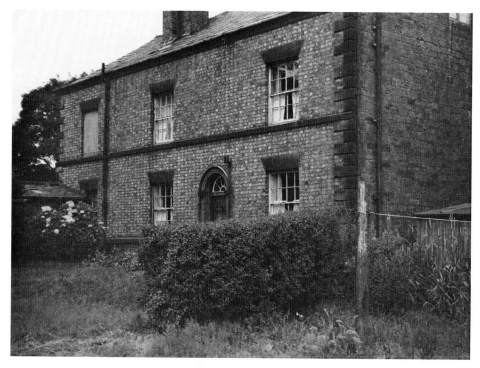

The shop was housed in the left-hand gable end of Thornside farmhouse, which is pictured here.

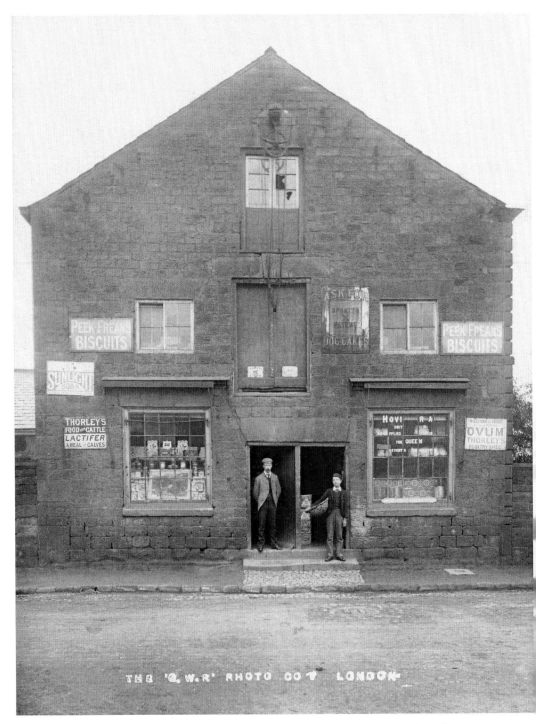

There is sadly no date on this late Victorian image, taken by the GWR Photo Co. of London. Advertisements for animal feed and a hayloft and hoist reflect the agricultural nature of the area at the time. Were these two father and son, dressed in their best for an occasion, or just for the photographer? Judging by the worn step, the shop had served the village community for many years.

4

BELLE VALE

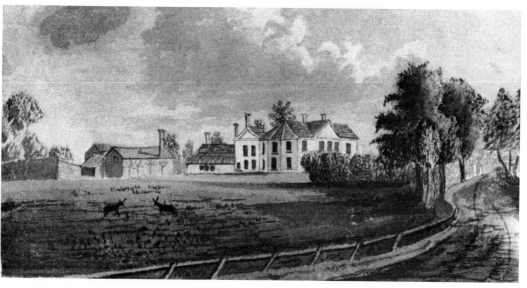

Belle Vale Hall, the old estate on the corner of Wambo Lane, in an illustration, *c.* 1815. In 1901 it was the home of Thomas Harrison, merchant and ship owner. The actor Rex Harrison, who was brought up in nearby Huyton, remembered visiting his eccentric grandmother at the house when he was a boy. The estate had a white-painted lodge on Belle Vale Road and was enclosed by high stone walls. When advertised for sale in 1916, the twelve acres included stabling, three coach-houses and outhouses, a tennis ground, cricket pavilion, paddock, glasshouses, a conservatory, gardener's cottage and kitchen garden as well as a private laundry, spring and well and three model cottages. By 1923 it had become a fruit farm, with the hall ending its days as the registered office of Belle Vale Orchards Ltd, preserve manufacturers, then being demolished in 1929. The jam works throughout the 1930s and '40s was owned by John Irwin Sons & Co. Ltd. After 1960 the factory changed from jam to spam, first as Blue Cap Foods and then Newforge. The site is now occupied by Morrison's supermarket and petrol station. (Courtesy of Liverpool Record Office, Liverpool Libraries – Binns Collection vo.12, p.19)

Belle Vale was a separate hamlet within the Little Woolton district, with just a few cottages, close to the ancient Belle Vale Hall. Well named as 'beautiful valley' its sandy soil was ideal for cultivation, dairy farming and fruit growing. At the end of the Second World War, one of the biggest prefabricated housing estates in England was built in Childwall Valley and Belle Vale, under the Temporary Housing Programme of 1944 to 1949. Then from the mid-1960s the whole area was cleared for new housing, schools and a shopping precinct. Part of the grounds of the original Belle Vale Hall estate survived to become the very pleasant Belle Vale Park.

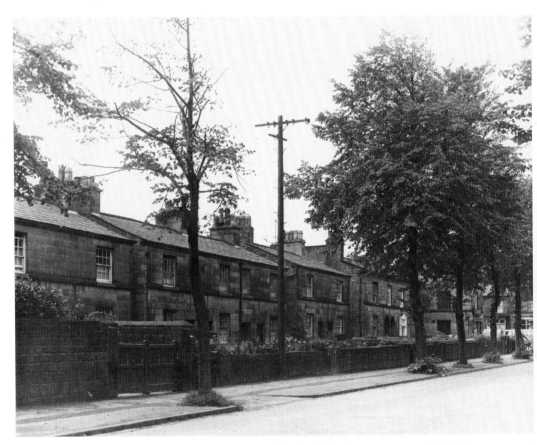

Stone Cottages, Gateacre village. The Greenoughs, a family of local stonemasons, built this row of nine sandstone cottages in Belle Vale Road between 1830 and 1845. As listed buildings they have remained relatively unaltered ever since. The cottages and their neat front gardens are an attractive asset, adding character and charm to the village scene. This photograph was taken by the city engineer's department in July 1957. (Courtesy of Liverpool Record Office, Liverpool Libraries, ref. 17402)

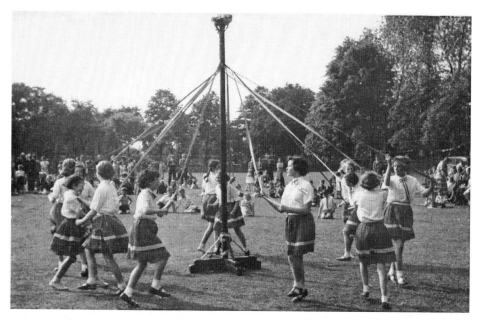

Alongside the former railway embankment in Belle Vale Road is Gateacre Recreation Ground. The photograph shows maypole dancing in 1953 – a coronation year celebration perhaps? This was where Gateacre cricket club played their matches and people still call it the cricket field. Football was also played, and there was a tennis court and a bowling green.

Opposite the recreation ground was the white-painted dairy farm known as Guy's Cottage, which, before the arrival of the railway, had been part of the original Belle Vale Farm. Mrs Ethel Guy still had a small shop there in the 1960s, when the land behind was the depot for landscape gardeners, E.H. Williams. There is now an apartment block, Woodholme Court, on the site. On the right of this photograph can be seen the access gate to Gateacre Station.

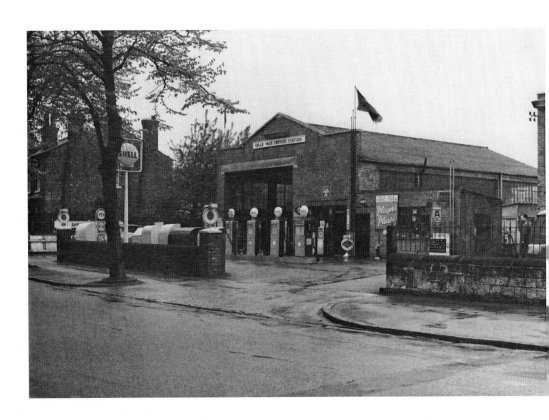

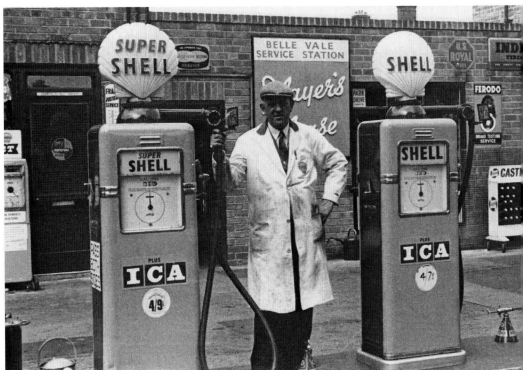

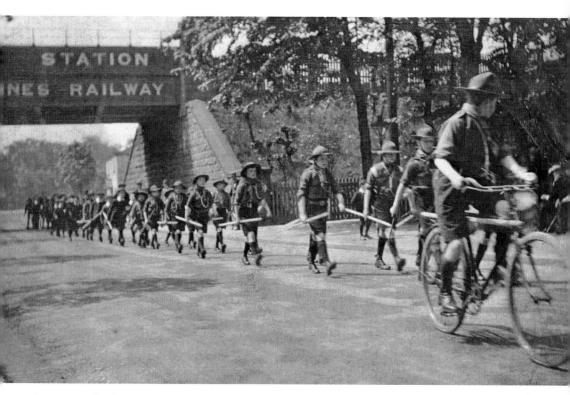

Scouts parade along Belle Vale Road before the First World War, probably on their way to St Stephen's Church. The wording on the railway bridge is 'GATEACRE STATION CHESHIRE LINES RAILWAY'.

Opposite above: The Hulme Brothers' Belle Vale Service Station opened in 1952, on what had been the orchard of Guy's Cottage. Charles A. Hulme & Co. Ltd were coal merchants and dealers and Charles A. & H. Hulme were haulage contractors. They ran the coal business from the railway siding, next to the recreation ground, where there was a shed and a weighbridge.

Opposite below: At the petrol pumps is George, one of the three Hulme brothers. During the Second World War the family had worked the farm at Throstle Nest, one of the oldest estates of Little Woolton. This very old house, farm buildings and the lodge – on the other side of Belle Vale Road just beyond the railway bridge – were all removed to make way for new housing, after compulsory purchase in 1951.

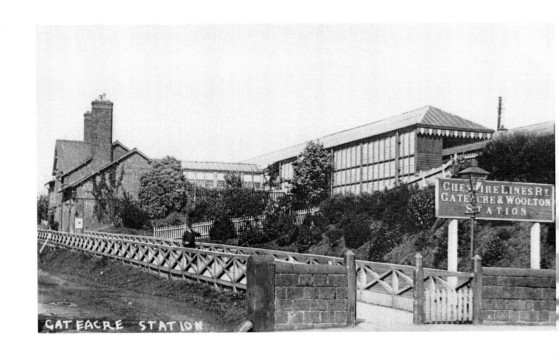

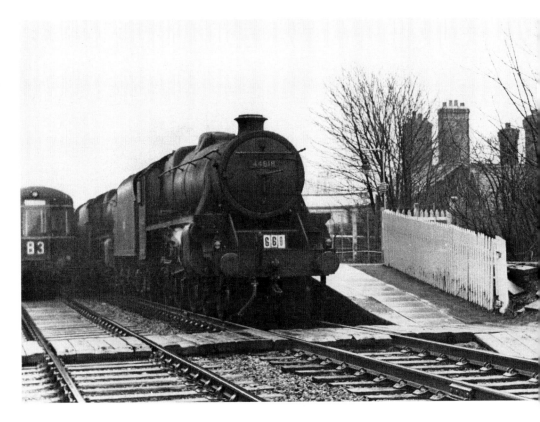

William Hall Walker presented the people of Gateacre with a 'promenade' – a footpath shaded by chestnut trees – on the route between the village and St Stephen's Church, to mark Queen Victoria's diamond jubilee in 1897. He also put up this ornamental signpost on Belle Vale Road to commemorate the occasion. In the background is one of the prefabs on the Belle Vale estate, which from 1947 provided 'temporary' accommodation for over twenty years.

Opposite above: Gateacre railway station opened to passengers in January 1880 and closed in April 1972. This northern branch of the Cheshire Lines Railway ran from Hunts Cross to Walton-on-the-Hill and was later extended to Southport. Trains ran to Liverpool Central via Hunts Cross. Russian royalty are said to have alighted here when visiting Gateacre Grange for the Grand National Races at Aintree. On the left-hand side is the booking office and station master's house.

Opposite below: Engine Nos 44818 and 44806 pass Gateacre station on 29 March 1958. In 1881 the stopping train from Liverpool Central to Gateacre took only twenty-five minutes. This North Liverpool line proved valuable during the Second World War as an essential link to the docks. As a Sustrans cycleway and footpath, the line is now part of the Trans Pennine Trail.

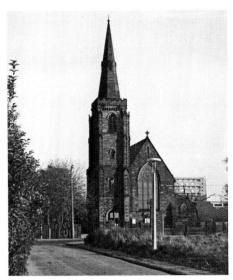

The Church of St Stephen was built between 1872 and 1874. Initially it was a chapel of ease to Childwall parish church, but in 1893 Gateacre was made a separate parish and St Stephen's became the parish church. The splendid west window, an Edward Burne-Jones design for William Morris & Co., was the gift of Sir A.B. Walker in memory of his first wife, who died in 1882. A choir vestry was added by his son, Colonel W.H. Walker, in 1897. The first marriage in the church register is that of Emily Crosfield Forwood, the daughter of Sir A. Bower Forwood of The Priory, Gateacre, to Henry Grey Kellock on 26 September 1893.

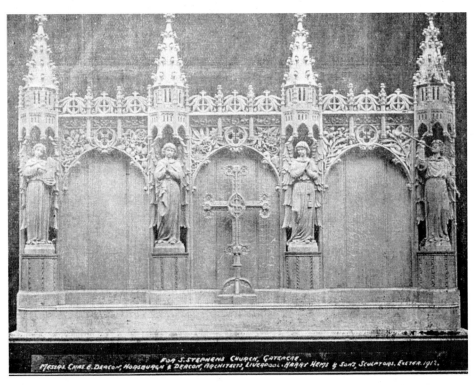

In St Stephen's Church there are memorial tablets for Sir A.B. Forwood MP; Edward Gibbon JP, who laid the foundation stone; and one for the twelve Gateacre men who died in the Second World War. Their names are also inscribed on the stone memorial cross in the garden in front of the church, together with the names of those who gave their lives in the First World War. The chancel screen was presented by Colonel W.H. Walker in memory of his father and the carved oak reredos, pictured here in an illustration from the 1924 Jubilee Handbook, was given in memory of Thomas Harrison by his widow in 1912.

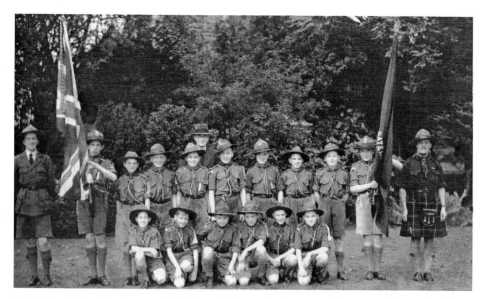

St Stephen's Church scouts, *c.* 1938. From left to right, back row: -?-, Harold Grieves (with flag), Don Harding, Tony Jones, Stan Molyneux, Revd W.H. Royden, Stan Marsh, ? Johnson, Joe Stevens, Norman Bassi, Colin Vardy, -?-. Front row: Douglas Wright, Roy Crosby, Charlie Windsor, Les Woodhouse, Jack Kerr, George Soul.

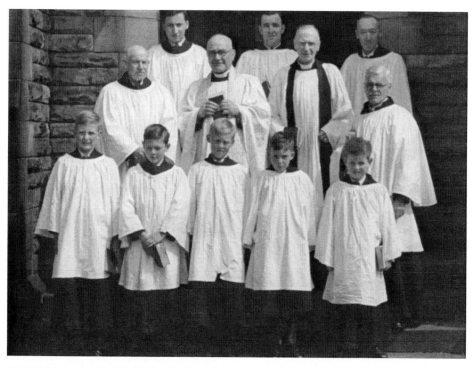

A 1946 photograph of St Stephen's Church choir. From left to right, back row: Eric Rothwell, Christopher Gibbons, Douglas McIver. Middle row: Jack Phythian, -?-, Revd W.H. Royden, Mr Elliot. Front row: Brian Bunting, Paul and Tony Hemesley, Tom Adamson, -?-.

Church Cottages were twelve model cottages next to St Stephen's Church, built in 1880 by Sir A.B. Walker for his estate workers and sometimes referred to as Walkers Cottages. They were designed by the Liverpool architect Cornelius Sherlock, who had also designed St Stephen's Church. The cottages remained part of the Walker estate until 1917, when this photograph appeared in the auction sale catalogue. The catalogue described them as 'forming a Miniature Garden City'!

This compact house of red brick was called Lee Vale and stood in its own grounds, next to Church Cottages and almost opposite Belle Vale Hall. During the bombing raids of the Second World War, the Valentine family and their relatives all took shelter in the cellars.

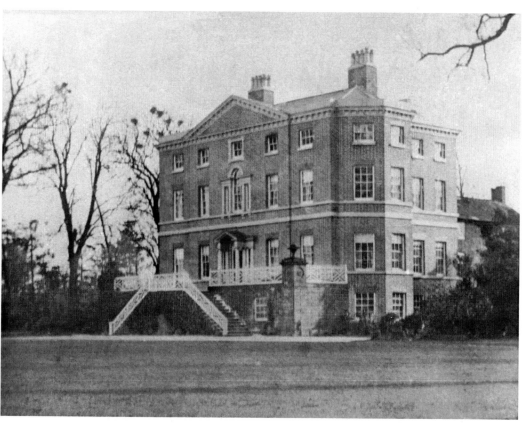

Lee Hall was a beautiful Georgian mansion built in 1773 by Liverpool shipbuilder and timber merchant John Okill. The house then passed to his nephew, James Okill, and then to James's son John Okill jnr, who died intestate in 1851. The heir to the estate was the son of his cousin, Thomas Dutton. The last Dutton to live at the hall was William, one of Thomas's four sons. Unfortunately, in the 1870s, he lost money investing in the Portuguese wine trade. John Hays Wilson then became the occupant until 1881, opening the lovely Lee Hall gardens and greenhouses to the public on several Sundays during the year; this photograph dates from that time. From 1890 to 1903, Dr Richard Caton MD, FRCP, lived at the hall. He was Professor of Physiology at Liverpool University and Lord Mayor from 1907–8. The hall and Lee Hall Park remained in Dutton family ownership but the building lay empty and neglected for nearly sixty years. The farmland was eventually sold in 1953 for a golf course. Most of the rest of the extensive parkland was taken over by Liverpool City Council, becoming the Lee Park housing estate. A ruin beyond repair, the Hall itself was finally demolished around 1960.

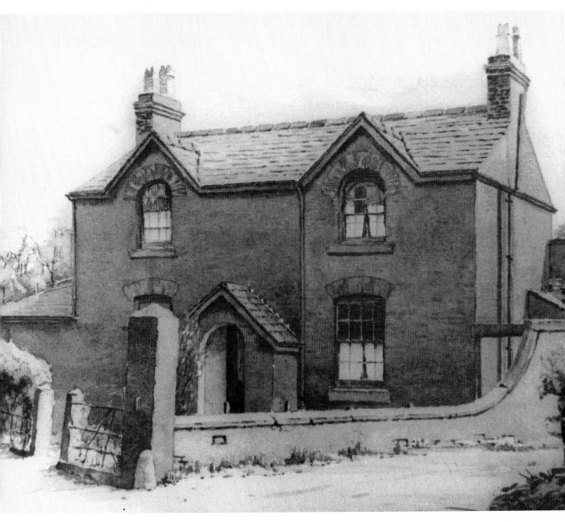

One of the cottages on the old Belle Vale estate, Wambo Lane, from a watercolour painting by Alfred H. Jones, 1948. It was called Belle Vale Cottage, but was always known as Mrs Seed's Cottage after the lady who lived there for many years. (Courtesy of Liverpool Record Office, Liverpool Libraries, AHJ Collection 76)

Right: Judith and Margaret Shorten, two happy little girls from No. 40 Charlwood Road on the Belle Vale prefab estate, *c.* 1949. Belle Vale District Shopping Centre opened in 1973, on the site where Charlwood Road had once stood.

Below: Belle Vale County Primary School infants make music in 1952, the year in which the school opened. Standing in the second row, fourth from the left is Judith Thomas, who is holding a tambourine.

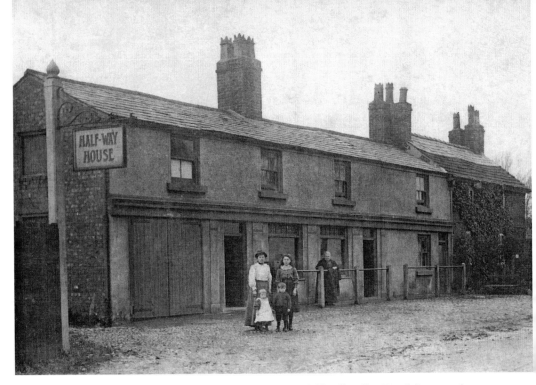

Pinfold Cottages on the old Belle Vale Road (now part of Childwall Valley Road) became the Halfway House pub. Belle Vale fire station now occupies the site.

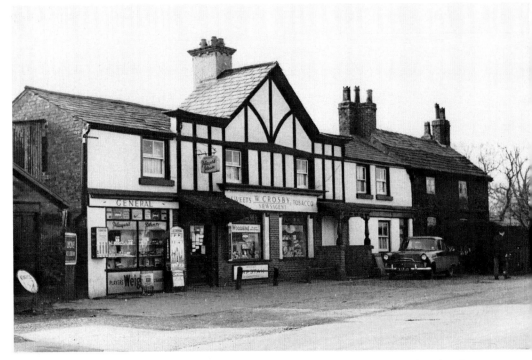

The Halfway House later became Crosby's sweetshop and newsagents. The right-hand end was Soul's (or Ivy) Cottage.

Opposite the Lee Park Golf Club entrance was Garden Lodge, seen here in this front-and-rear composite view, which was demolished in 1967 by Liverpool City Council to make way for the new Netherley housing estate. One of the massive blocks of flats on this development was given the name Garden Lodge Grove as a reminder of what had gone before. The flats proved very unpopular with tenants, and have since been demolished.

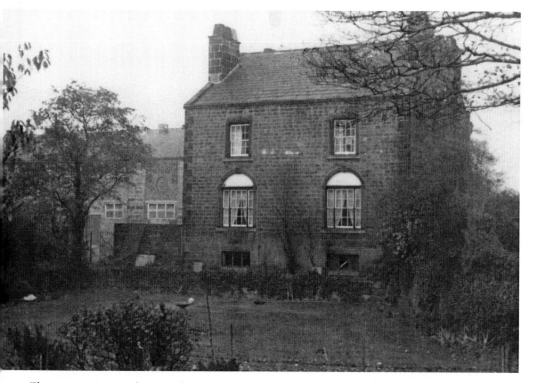

The very ancient settlement of Brettargh Holt was in the area we now know as Netherley. Our photograph shows Holt Hall Farm in Holt Lane, where Arthur Humphries and his sons Roy and Jed were farming in the 1950s. John Scotson, a member of the Little Woolton Local Board, was the farmer in 1881.

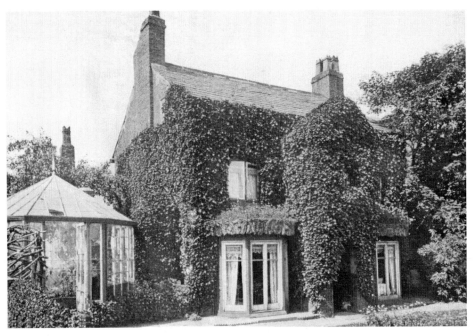

This pretty farmhouse, with a neat conservatory at the southern end, was known as Ivy or Naylors Farm. It was part of the Walker family's property, and this photograph was included in the 1917 auction catalogue. The farmhouse stood on the west side of Naylors Road, just to the north of the present-day junction with Brinton Close.

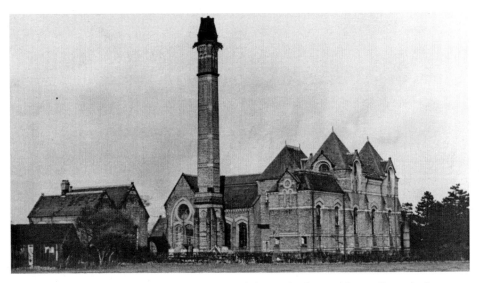

The Little Woolton township boundary followed the Netherley Brook, a tributary of the Ditton Brook which enters the Mersey at Widnes. Just before Netherley bridge were the Netherlee (original spelling) Waterworks and workers' cottages, built by Widnes Corporation around 1880–83. The engines had names and the main pumping engine built by Hawthorne Leslie was called *Benjamin Brown*. The four cottages are still there but the waterworks buildings were demolished in 1954.

5

HALEWOOD ROAD

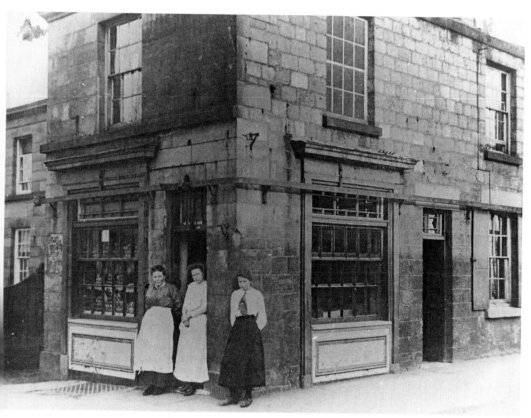

There was a building on the corner of Belle Vale Road and Halewood Road before 1835 and for much of its life the site has been occupied by a butcher's. The first, John Taylor, bought the 'shop, cottage, garden and yards' at an auction at the Bull Inn, in 1868. John Blackmore, the butcher and beerseller in 1884, was allowed to graze five sheep on the recreation ground, at 4d per head a week. From 1912–22 the shop was called Mercers, and this photograph probably dates from that time.

The line of Halewood Road followed an ancient packhorse route called 'the Portway', which led southwards to a ford across the River Mersey. The boundary between the two Wooltons (Much and Little) ran along its length, so all the property on the west side lay in the Much Woolton township. However, both sides of Halewood Road, as far as Out Lane, have always been regarded as part of Gateacre. The name was changed from Lane to Road by the Little Woolton Local Board in 1868. One of the oldest settlements in Little Woolton lay on the eastern side of the lane and was called The Nook.

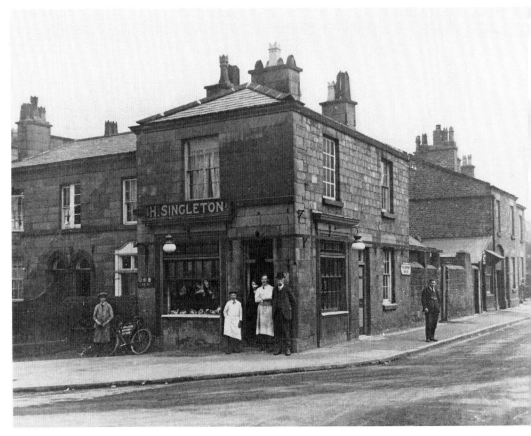

Henry Singleton was the butcher in the late 1920s. The straps around the building were perhaps used for hanging up the meat, fowl or rabbits. The unusual white arts-and-crafts window surround, next door at No. 1 Stone Cottages, tells us that this was the former beerhouse. It was there until just before the First World War and was called, we believe, the Railway Inn.

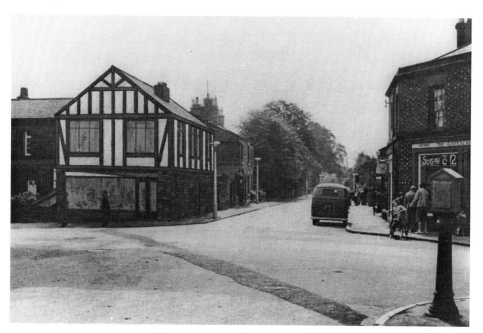

A building that never was! J.E. Morphet & Sons, butchers, submitted a design for rebuilding the premises at Nos 1 and 1A Halewood Road in 1957. This 'suggestion' for the new shop would have given Gateacre yet another black-and-white building, but it was rejected by the planning authority, who decided it should be built from the local red Woolton sandstone.

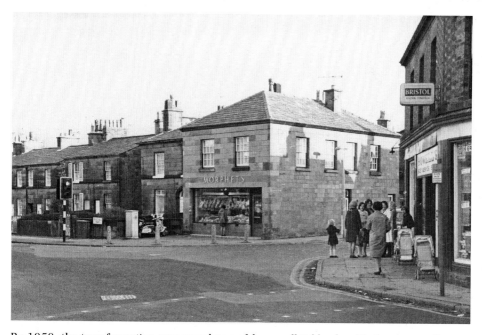

By 1959, the transformation was complete and how well it blends with the surroundings. This photograph was taken in 1966, since which time the premises have been occupied by Gateacre post office (unfortunately lost in the recent spate of closures) and, more recently, a funeral director.

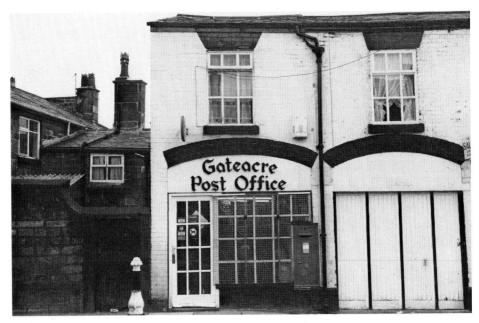

Percy Johnson was a boot and shoe repairer at No. 4A (now 3A) Halewood Road in the 1930s and '40s. The shop became the post office for a short time around 1980–85. The numbers were still even in 1966 when George Corbishley, a haulage contractor, was living at No. 4 (now No. 3).

These three nineteenth-century cottages, now numbered 5, 7 and 9 Halewood Road, appear relatively unaltered today. When first built, however, they were back-to-back properties and in the 1880s at least six families lived here, with just one tap between them.

Right: Rosie Harris (on the left) outside No. 8 (now No. 5) Halewood Road. She became a dressmaker but also taught piano, and her brother Walter played the organ.

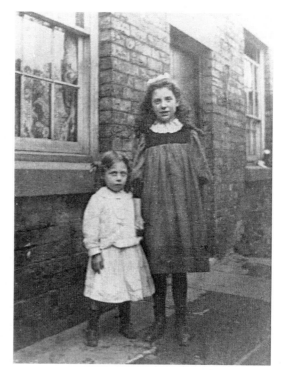

Below: Woodholme is the front part of an early nineteenth-century house once called The Lindens. After it was divided in 1963/4 the back was renamed Linden Cottage. In 1974, Tim Brakell became the first chairman of the Gateacre Society and this was the Brakells' family home for many years.

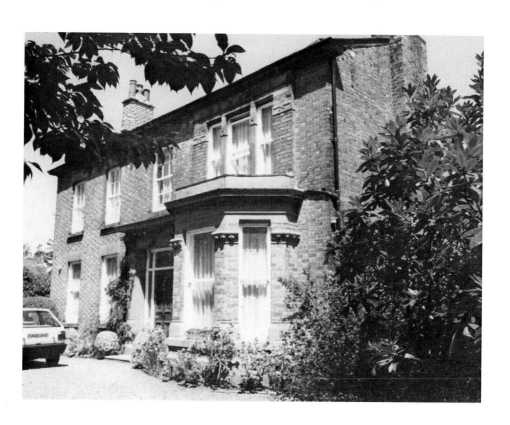

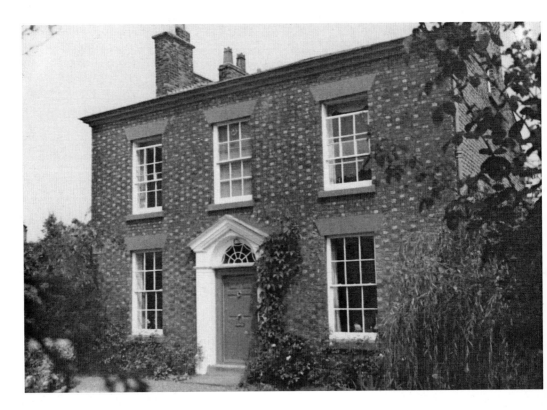

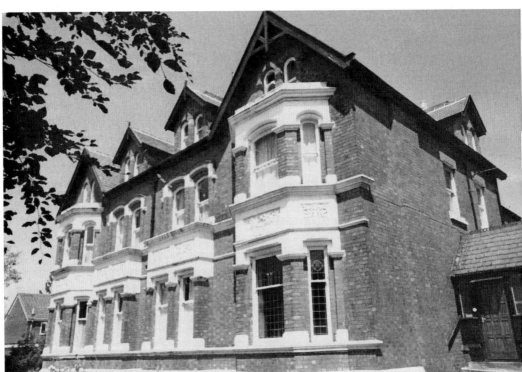

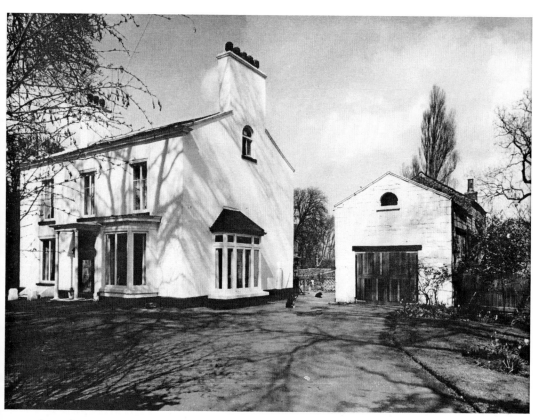

Elm House is shown on the Little Woolton enclosure map of 1845, but was demolished in the 1960s. James P. Reynolds and his young wife lived here when newly married. Edgar L. Trant RD, RNR, commodore of the White Star shipping line, lived here until 1953 and the last occupant (and owner of this photograph) was a Mrs Hughes.

Opposite above: Kingsley is typical of the red-brick houses built in Gateacre from around 1840. Prior to 1840 they were mostly stone built. It is a listed building within the conservation area. James Hubert Blundell ran a smithy here in the 1930s.

Opposite below: These red-brick semi-detached villas of 1883 were named Red Lyn and Elvet House. They became St Gregory's Mission, a training establishment for Roman Catholic priests, over fifty years ago. The building is situated just outside the conservation area, and in 2009 planning permission was granted for its demolition, to make way for a sheltered housing block.

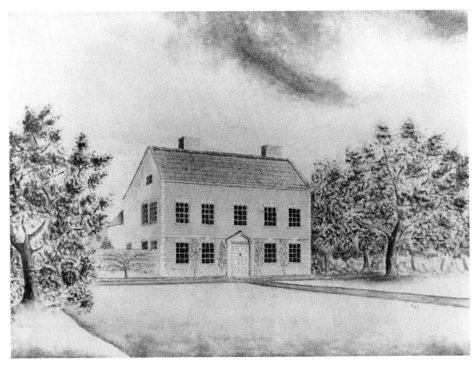

One of the earliest settlements in Little Woolton was The Nook, a sheltered spot in a green vale, just off the beaten track on the east side of Halewood Road. This is an early 1800s drawing of the house facing Halewood Road, which in 1798 was named Mersey Vale by the Nicholson family. By the 1880s it was called The Laurels and a century later it formed the nucleus of the popular Gateacre Hall Hotel.

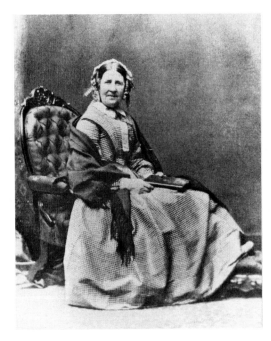

Miss Dorothy Nicholson (1803–1893), Unitarian and advocate of the Temperance Movement, was born at Mersey Vale and lived there for most of her life. In 1862 she read the address when a library and reading room was opened at the Mechanics' Institute in Woolton village.

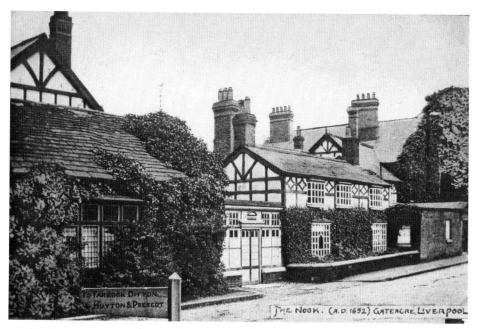

This Edwardian postcard view shows two picturesque cottages which stood in Nook Lane. The date 1652 appeared above a doorway inside the right-hand cottage. These two buildings became incorporated into alterations and additions by various owners of the property during the nineteenth and twentieth centuries. Such a hotchpotch of building that, when examined by the conservation officer in 2003, they were declared 'not worth saving'!

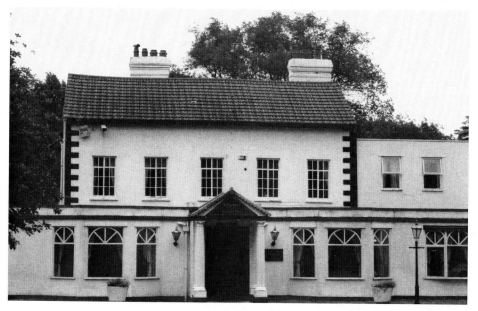

The complex of buildings, old and new, opened as the Gateacre Hall Hotel in 1964 and closed, prior to demolition, in October 2003. It was a popular venue especially for wedding receptions, for nearly forty years. The site is now occupied by apartment blocks called Woodsome Park.

The garden entrance of buff-coloured Triassic stone, which is eighteenth century (or earlier), is a listed building and so escaped demolition in 2004. The gate has a local nickname, the Slave Gate, as legend suggests it was brought here from the Liverpool waterfront where it had connections with the slave trade.

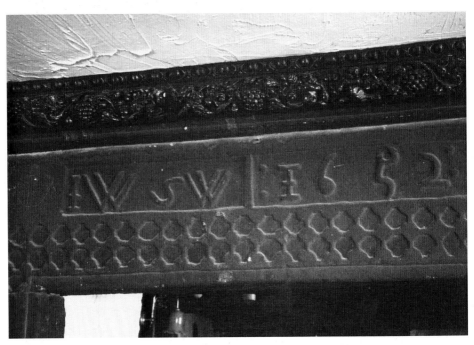

The stone doorcase and lintel of a cottage, bearing the initials of John and Sarah Williamson and the date 1652, could at one time be seen inside a bar at the Gateacre Hall Hotel. This was the one little piece of history which, at the request of the Gateacre Society, the developers agreed to save. It was dismantled stone by stone, taken away for cleaning, and then re-erected in the courtyard of the apartments built on the site in 2005.

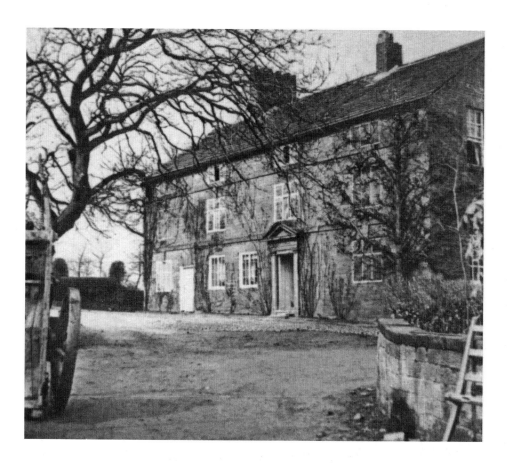

Above: The original house named The Nook, where Revd William Shepherd had his renowned 'Gateacre School', was at the far end of the lane. Prior to demolition for the building of the railway in the 1870s, it was the Gateacre Chapel ministers' residence for over 130 years.

The Nook, Gateacre, Nr. Liverpool.

Right: In this early sepia postcard, the old Nook Farm barns can be seen through the railway arch. The public footpath which led under the railway, across Nookfields to Halewood, is still in use today.

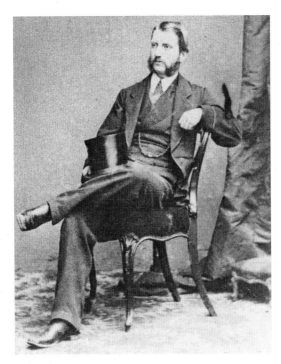

Ship owner Charles William Jones (1842–1908) was a founder of Liverpool University, where he first provided the means for athletic training. The eldest son of Unitarian minister Revd Noah Jones, he spent his boyhood at the (old) Nook.

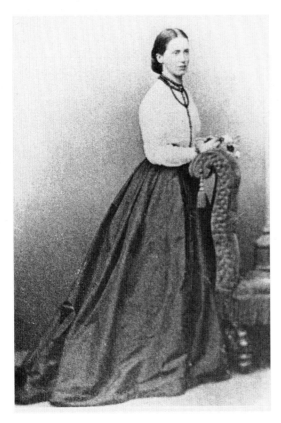

Charles' brothers and sisters were Louly, Emily (pictured here), Frances and Edward Jones.

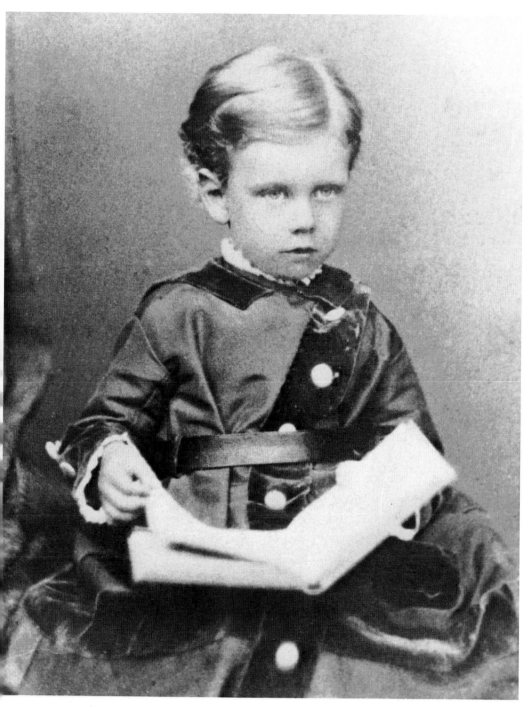

This little boy, born in 1872, was the grandson of Noah and the son of Charles William Jones. He became Sir C. Sydney Jones, a partner in the Alfred Holt shipping line, who was High Sheriff of Lancashire in 1929 and Lord Mayor of Liverpool 1938–42. He was a patron of the arts, and a generous benefactor to the University of Liverpool. Sir Sydney died in 1947 and a Liverpool University library bears his name.

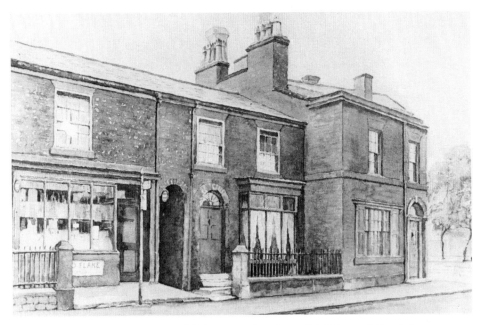

The block of cottages Nos 1, 3 and 5 (now numbered evenly) Halewood Road, from a watercolour painting by Alfred H. Jones, 1947. Miss Lilian Brown ran the much-loved sweetshop at No. 5 for the next twenty years. (Courtesy of Liverpool Record Office, Liverpool Libraries, ref. 18/J5)

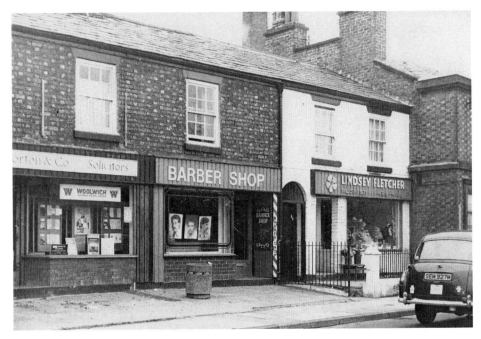

No. 5 (now No. 6) Halewood Road became 'Christine and Norman's' hairdresser's, then the very popular barber shop where Norman kept customers up to date with local news. No. 8, next door, underwent renovation a few years ago and was changed back from a shop to a cottage.

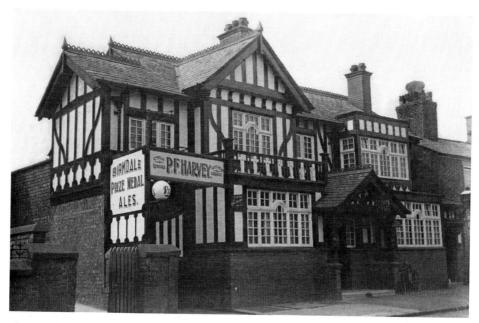

The Brown Cow public house was originally two cottages which were extended and given new windows and a black-and-white frontage by Walker's brewery in the late nineteenth century. It is shown here in around 1934, when Mary Jane Rothwell was the licensee and Harvey's garage premises were in the yard at the rear.

A sit-up-and-beg dog and an Austin Riley, with the Brown Cow and a distant view of the Wilson memorial fountain, all feature in a tiny snapshot from 1938.

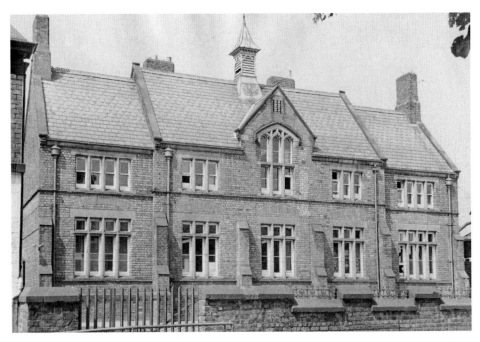

In 1877, Sir Andrew Barclay Walker gave a plot of land in Halewood Road for the building of a new school. This truly Victorian, Gothic-style building of 1878 replaced the old National School on Grange Lane. Called at first, Little Woolton and Childwall Church of England School, it later became known as Gateacre Church of England School. After closure in 1990 the building was converted into flats and renamed St Stephen's Court.

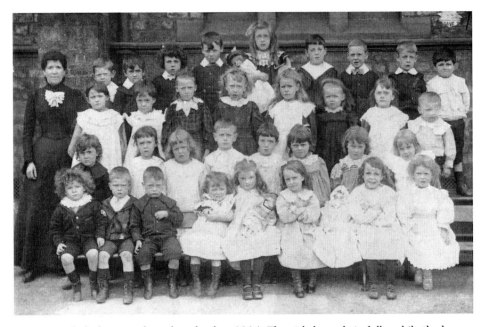

Four rows of obedient pupils at the school, c. 1914. The girls have their dolls, while the boys sport lace collars. Third from the right in the front row is Florrie Rylands, aged about four.

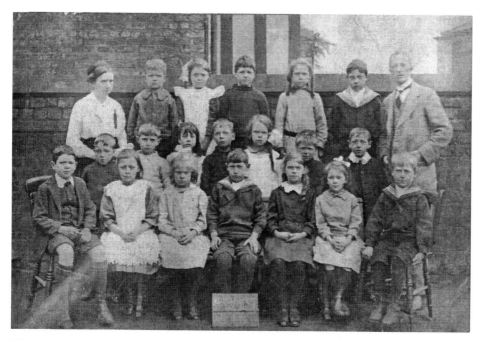

Edna Johnson, now Mrs Thomas, is seen here third from the left in the front row, *c.* 1916. She remembers the teachers' names as Miss Broom and Mr Platt.

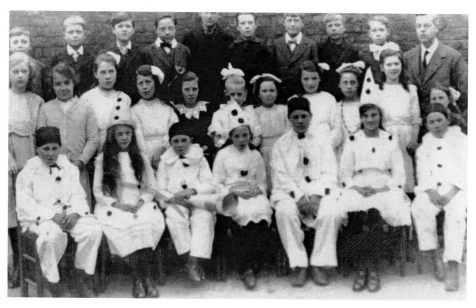

Pierrots and pierrettes taking part in a school concert in 1918. From left to right, back row: S. Birchall, George Welch, Rex Harrison, George Jackson, Will Rylands, Arthur Hughes, W. Humphries, Jimmy Davis, Mr Platt. Middle row: Lily Welch, Beattie Johnson, Maud Lloyd, Peggy Woolfall, Connie Hulme, Edna Johnson, Jessie Southern, L. Glover, Rosie Harris, Winnie Roycroft, Emmie Elson. Front row: Leonard Pinnington, Maidie James, Cecil Harding, -?-, Stanley Sefton, Phoebe Pye, -?-.

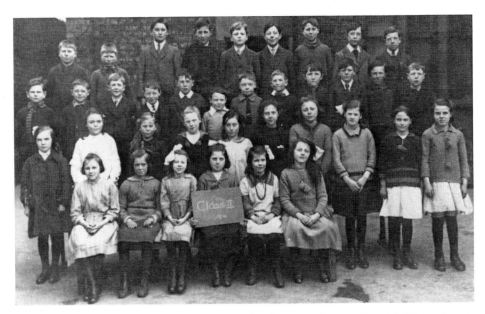

This photograph, taken in 1922, has Florrie Rylands age twelve standing third from the right in the second row. The girls wear knitted stockings and sensible leather shoes or buttoned boots. Unfortunately, none of the other pupils' names are known.

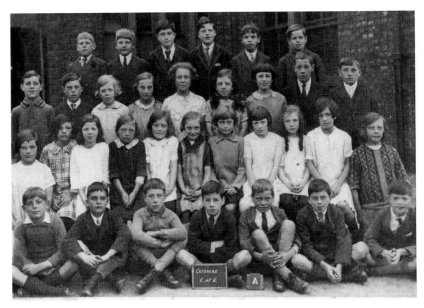

Gateacre Church of England School, Class A., c. 1927. From left to right, fourth row: -?-, Charlie McDougall, Billy Broadbent, Charlie Hughes, Tom Radley, -?-. Third row: E. Leather, -?-, Bunty Williams, Annie Hayes, Lily Wyke, May Hesketh, -?-, Josslyn Johnson, -?-. Second row: Edna Dykins, Jane Woodhouse, Lily Rothwell, D. Hesketh, Mabel Dykins, Nellie Hayes, G. Trembath, -?-, Phyllis Harding, Annie Finney, F. Hesketh. First row: -?-, Roland Capstick, Ernest Wright, -?-, Harry Wilson, Freddie Hazell, Sydney Carroll. Ernest Wright was killed at Tobruk in December 1941. Harry Wilson was in the RAF and died in the war, August 1940.

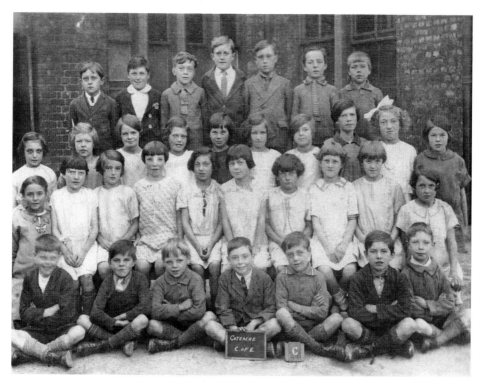

Gateacre Church of England School, Class C, *c.* 1930. From left to right, fourth row: John Capstick, Alan Hewitt, Teddy Hounslea, Norman Williams, A. Williams, Tom Leather, Harold Humphrey. Third row: Emily Hayes, Clara Turton, Dorothy Jones, G. McDougall, -?-, -?-, -?-, ? Kerr, Mary Thwaite, Laurie Packer. Second row: M. Guy, May Hughes, -?-, Peggy Turner, Tessa Guy, Lily Trembath, Annie Finney, Hilda Conlon, Ivy Battersby, Frances Jones. Front row: William Turton, Jack Birchall, Herbie Hesketh, Leonard Harding, William Wright, Billy Iddon, Jack Kerr. William (Teddy) Hounslea was killed on 12 September 1944 and Norman Williams on the 30 January 1944.

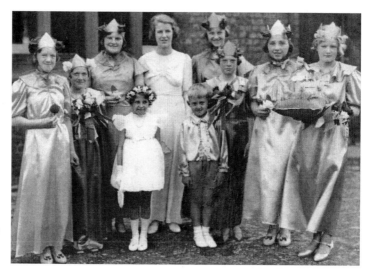

Rose Queen, *c.* 1938. From left to right: Mary Prickett, Dorothy Lee, Dorothy Dykins, Doris Crosby, Louise Johnson, Muriel Gould, Olive Stephens, Betty Owen. In the centre are Gabrielle Lee and Rex Clegg.

Above: This is Rose Cottage where the family of Josslyn Johnson, cabinet maker, grew up. Dora, age eight in 1921, stands at the gate of what was then No. 19 but is today No. 78 Halewood Road.

Left: The Johnson girls are pictured here wearing black stockings – knitted by their mother – and their best white pinafore dresses. On the left is Edna, with Anna, Dora, Josslyn jnr and Uncle Harry.

A wartime photograph of the Johnson brothers and sisters. From left to right: Jock, Dora, Louise, Edna, Anna and Fred.

A Townswomen's Guild outing to the Wedgwood factory in 1962. Edna, Dora and their mother Mrs Johnson are amongst the group.

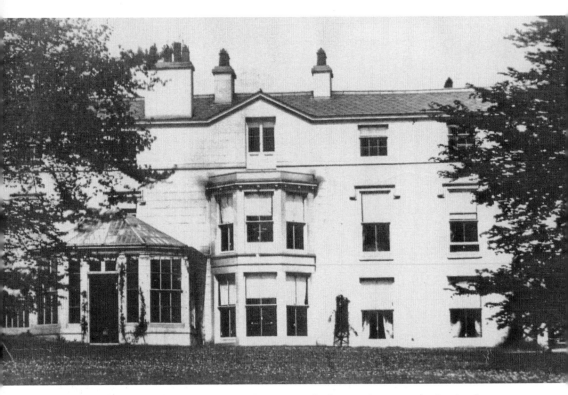

An 1870s photograph of Knotty Cross when it was the home of a cotton broker by the name of Robert Gill. Ella, Betty and Edward T. Owen grew up here before the Second World War. Blazaway Firelighters occupied part of the premises in the 1940s. The house – still here today but divided into flats – stands at right angles to Halewood Road, facing towards Out Lane.

6

ROSE BROW

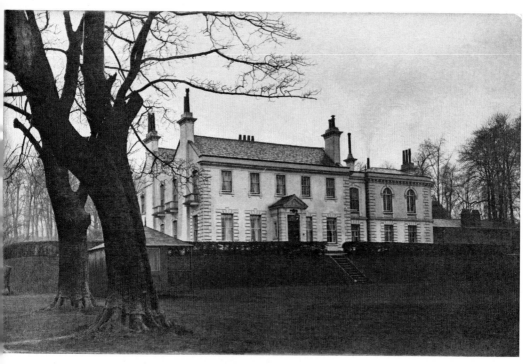

The Rosehill estate appears on eighteenth-century maps and the rent in 1799 was £30 per annum. The house stood high above the road with views of the Childwall valley below. One occupant was Edward Gibbon JP who, after Florence Nightingale drew his attention to the lack of nurse training, became the first chairman of the Liverpool Training School & Home for Nurses. The right-hand wing was an addition, by him, to the original house. Now demolished, its site is occupied by the Rosehill Court flats in Woolton Road.

Rose Brow once bordered the Rosehill estate and was part of the long straight road from Much Woolton across Childwall heath to Wavertree. In the 1830s this was called Gateacre Road, then it became known as Liverpool Road, and finally, in 1868, Woolton Road. The old Rose Brow ran as far as Black Wood but now only the short road from Cuckoo Lane to Gateacre Brow retains that name. In the 1860s, the wealthy brewer Andrew Barclay Walker came to live in Gateacre, building his mansion Gateacre Grange on the site of Higher Grange, Rose Brow.

Opposite Rosehill there was a white-painted house known as Gateacre Lodge, which was pulled down in the late 1960s for the building of Cuckoo Way and Cuckoo Close. Mr Place, who lived there in the 1930s, invited the village children to a bonfire night party in his garden every year. This view is from the garden at the back of the house.

Right: An early photograph, taken from the garden of Gateacre Lodge, of Woolton Road running uphill past the Rosehill estate. This may at one time have been a toll road: one of the cottages which used to stand on the corner of Cuckoo Lane was called by some the Old Toll House. A property advertisement in the *Liverpool Mercury* on 10 March 1871 referred to it as 'the turnpike road from Liverpool to Woolton'.

Below: Remembered by local boys as the driver of a shiny green Rover, but photographed here in a 1920s Humber, was Mr Richard Pinnington, chauffeur to Mr Place of Gateacre Lodge.

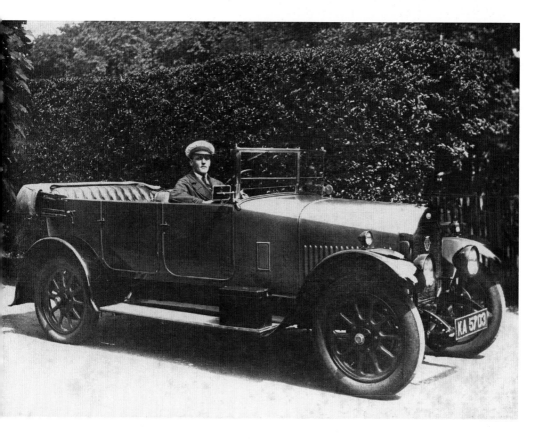

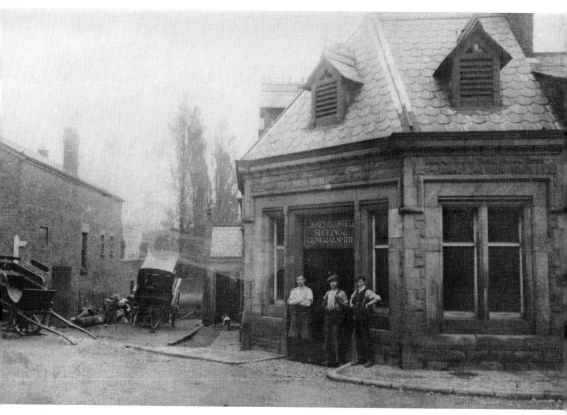

In the 1860s Sir A.B. Walker built a shoeing shed for his horses, in front of the old cottage. The blacksmith's services were also made available to the wider population. The last Blundell to work there as a blacksmith was Tom, in 1935. The building has had a number of uses since and today is a children's nursery. On the far left of this photograph, behind the cart, a small signpost points in the direction of the public footpath to Grange Lane, which has been in use for over 200 years.

Opposite above: The two adjoining cottages on the left, at the junction of Woolton Road and Cuckoo Lane, were called Rose Cottages. They were demolished in the late 1960s. The row of five on the right may have been built by the landowner William Barrow of Lower Grange for his estate workers. A sixth dwelling was added to the row in 2006.

Opposite below: Smithy Cottage is the building at the back of the old smithy, on the corner of Rose Brow and Cuckoo Lane. The first Blundell to live there – with his wife, eight children, and three apprentice blacksmiths – was James, in 1841. His blacksmith's workshop, where his sons learnt their trade, was on the corner of Sandfield Road, Gateacre Brow.

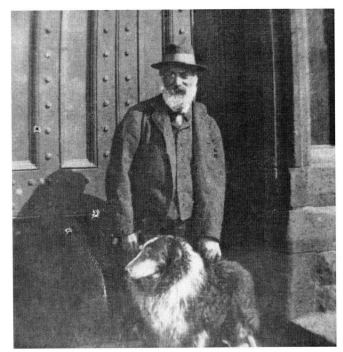

Left: At the smithy door in the early 1900s with his faithful collie is Mr James Blundell, grandfather of Grace, of Woolton, and James, of Gateacre Riding School.

Opposite above: Three large houses which stood on Cuckoo Lane until around 1980, commanding wonderful views of Childwall Valley, Prescot and beyond, were Hillside, The Slopes and Rockfield. This one, Hillside, was an imposing three-storey house on the corner of Oakfield Avenue, which prior to demolition had been divided into flats.

In 1936 Mr William Keen and his family moved from No. 3 Rose Brow to the cottage behind the smithy. All the children, Reg, George, Eric and their three sisters, have fond memories of growing up in Gateacre. Mr Keen worked as a gardener, first at Rosehill for Mr Tod then for Liverpool Corporation, but still found time to grow his own dahlias in the cottage garden. As an ARP warden during the Second World War he was the only person allowed to fit the nuns at Gateacre Grange (then known as the Virgo Potens Hospital) with gas masks.

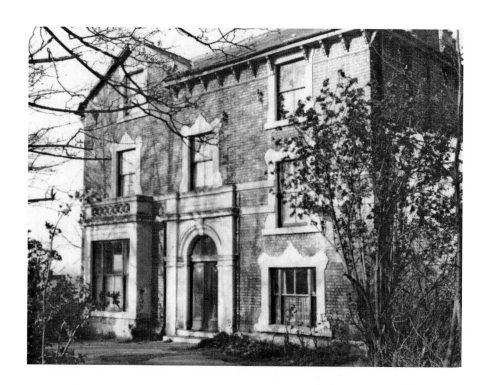

Rockfield on Cuckoo Lane, next to the ancient public footpath which ran downhill to Grange Lane, was similar in size and style to Hillside and probably built by the same architect, in the 1870s. After all three houses were demolished five new houses were built on the site between Oakfield Avenue and Rose Brow.

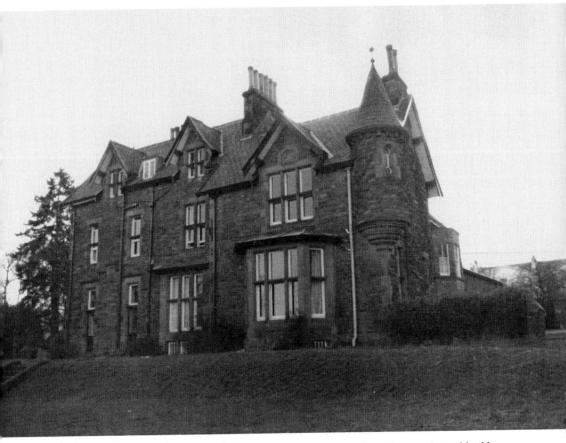

An impressive house, Oakfield was built in 1865 for Elkanah Healey, a Liverpool coachbuilder. During the Second World War it was used as the offices and distribution centre of the film company MGM. The film canisters, which were stored in the cellars, were sent to cinemas throughout the North West. In 1946 the house was bought by Liverpool Corporation, later becoming a special school and centre for handicapped and disabled children. Despite efforts for a reprieve, it was demolished in 1992. Its site is now occupied by the Meadow Oak Drive housing estate.

Opposite above: Rose Brow Cottages were perhaps originally stone built but have been rebuilt or refronted since in brick. With Union Jacks and bunting much in evidence, this photograph probably dates from coronation year 1953. Employing three men at his cobbler's shop in the old smithy building was the excellent shoe-mender Mr G. Shawcross.

Opposite below: Mr A. Mason, who had lived in Rose Cottage on the corner of Cuckoo Lane, gave this photograph to the Gateacre Society in 1977. It shows the five cottages with their window boxes, looking very neat and trim.

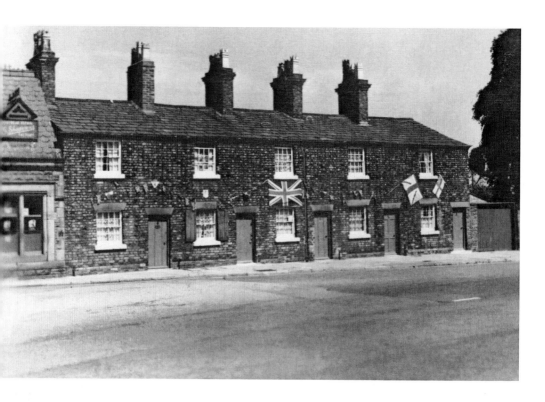

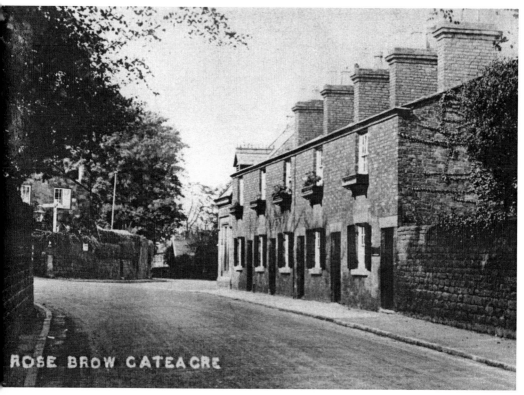

ROSE BROW GATEACRE

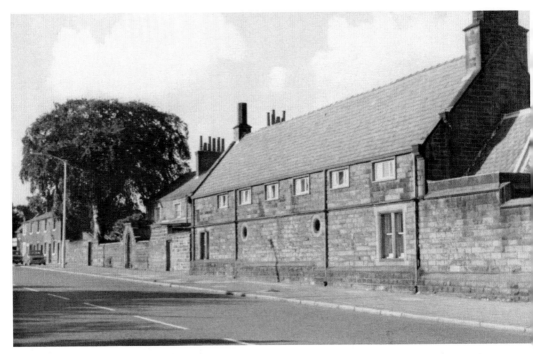

In the foreground is the stable block of Gateacre Grange which now has a new lease of life as mews housing. It was from these stables that, as a young man, James Blundell began a riding school. Sadly the magnificent beech tree in the grounds of the adjacent Grange Cottage (now known as Barclay House) suffered and died during building work on the site.

Opposite above: Sir Andrew Barclay Walker, Bt (1824–1893). A very pleasing portrait of a man who, as 'squire' of Gateacre, did much for the village and its inhabitants. Walker was a Scottish-born brewer, the company Peter Walker & Son having been founded by his father. The firm's head office was in Liverpool and it had breweries in Warrington and Burton-on-Trent. During his first term as Mayor of Liverpool (1873–4) Walker gave the town an art gallery, which opened in 1877. He was knighted in 1877, and made a baronet – the 1st Baronet Walker of Gateacre – in 1886. Walker also served as High Sheriff of Lancashire (1886–7). In 1884 he bought Osmaston Manor in Derbyshire as his new country seat and in 1887, having been a widower for five years, he married the Hon. Maud Okeover, one of Queen Victoria's ladies-in-waiting, who lived at Okeover Hall nearby. When he died in 1893, Sir Andrew left a vast fortune of over £2,800,000.

Opposite below: Gateacre Grange, seen here ivy clad in the early 1900s, was originally built for Sir Andrew Barclay Walker, and later occupied by his son William Hall Walker. The house was built in around 1866–9 by local architect Cornelius Sherlock, in Victorian Gothic style. The northern section was an addition, *c.* 1883–4, by architect Sir Ernest George. The grounds stretched from the garden terrace in two levels down towards Grange Lane, and across from Gateacre Brow to the old public footpath, now known as Grange Weint, off Cuckoo Lane. Sir A.B. Walker's third son, Colonel William Hall Walker inherited the estate in 1893 and was there until around 1916, when he left to live at Horsley Hall, Gresford near Wrexham. The house became St Vincent's College (a school for boys), Virgo Potens Hospital and then, in the 1960s, a home for retired seafarers, run by the Roman Catholic charity the Apostleship of the Sea. Gateacre Grange is now a Grade II listed building within the Gateacre Village Conservation Area, and all the trees on the site are covered by a Tree Preservation Order. It is at present being converted to luxury apartments for rent.

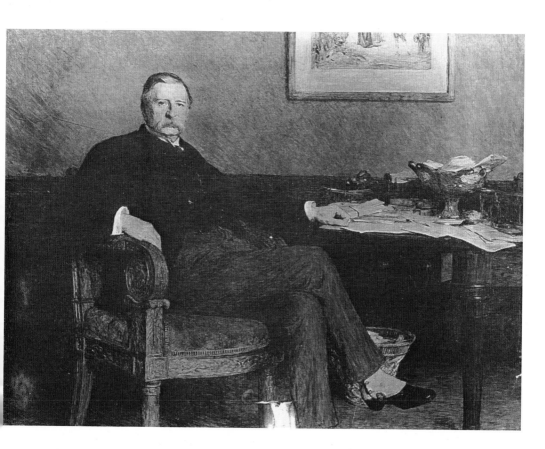

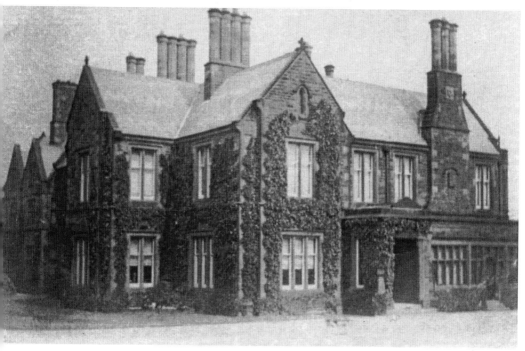

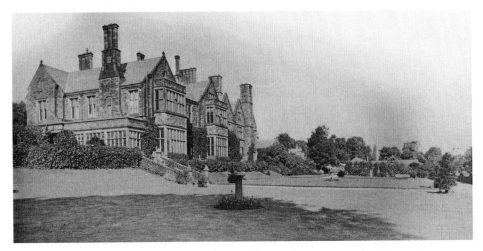

This view of Gateacre Grange, taken from the upper level grounds, is of the garden terrace at the back of the house. Note the Star of David (later removed) on the large chimney stack. (Courtesy of Liverpool Record Office, Liverpool Libraries).

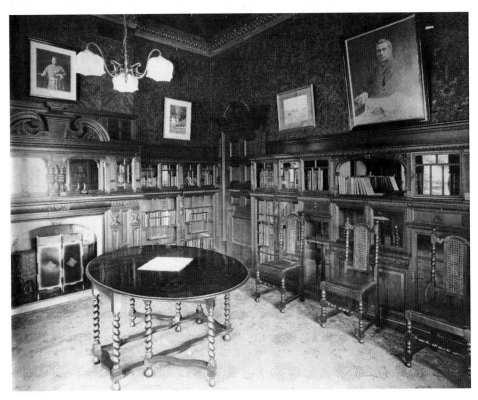

The ground floor library when Roman Catholics were in residence. In one bookcase was Andrew Barclay Walker's set of *Encyclopaedia Britannica* for 1868. The rector of St Vincent's College in 1927 was the Very Revd Joseph S. Sheehy CM. A former drawing room opposite the library was converted to become a Catholic chapel. (Courtesy of Liverpool Record Office, Liverpool Libraries).

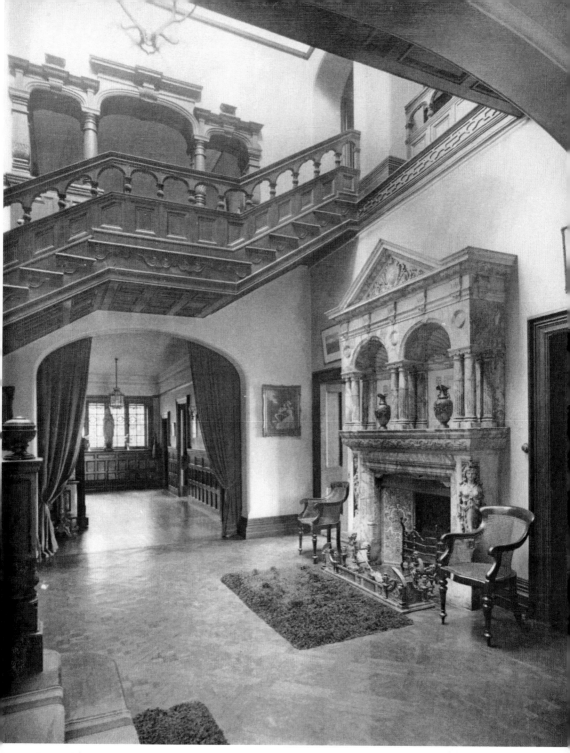

The very grand fireplace in the main hall of Gateacre Grange is of creamy brown alabaster, elaborately carved, and attractive portraits in stained glass are a feature of the windows beyond the arch. The flooring, panelling and wide staircase were all fashioned from oak. (Courtesy of Liverpool Record Office, Liverpool Libraries).

The Gateacre Grange football team poses below the terrace. In 1909/10 they played a match against the stable staff of 'Sandy Brow' and won. In the centre is Mr William Pinnington, seated right William Edward Pinnington, standing right Richard Pinnington. Sandy Brow, in Delamere Forest, was another of William Hall Walker's houses; an ideal base from which to pursue his 'country sports' interests.

Opposite above: Valet to Colonel Hall Walker, Mr Ricketts (front row second right) and eight other staff of Gateacre Grange. In the back row far left is Mr William Pinnington, whilst seated at the front is Richard Pinnington. Colonel Walker was Member of Parliament for Widnes from 1900 until 1919. During the election campaign of 1910, the staff etched their names and the words 'VOTE for WALKER' on the glass of the kitchen window.

This portrait photograph was given to Mr W. Pinnington in 1917. Colonel William Hall Walker (1856–1933) inherited the Gateacre Grange estate on his father's death in 1893. William Hall Walker was involved in the family brewing business, but his great interest was in playing polo and breeding racehorses. Apart from Gateacre Grange, he had a home in Delamere Forest (Sandy Brow) and a stud farm in Ireland (Tully, Co. Kildare). Every time a foal was born, Walker would cast its horoscope. Only if the horoscope was favourable would the foal be kept and raced. In 1916 Walker gave the stud to the British Crown – with a view to improving the quality of cavalry horses – and in 1919 was rewarded with the title Lord Wavertree. Still in existence at Tully, it is now the Irish National Stud.

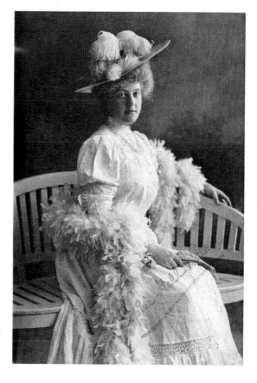

Mrs Sophie Hall Walker, sixteen years younger than her husband, was the great-great-granddaughter of the playwright, poet and politician Richard Brinsley Sheridan. Like her husband, Sophie was passionate about sport, being a sponsor of the fashionable new game of lawn tennis. After her husband's elevation to the peerage Sophie – as Lady Wavertree – spent much of her time in London, where her home in Regents Park was the venue for Exhibition Lawn Tennis Matches in aid of various charities.

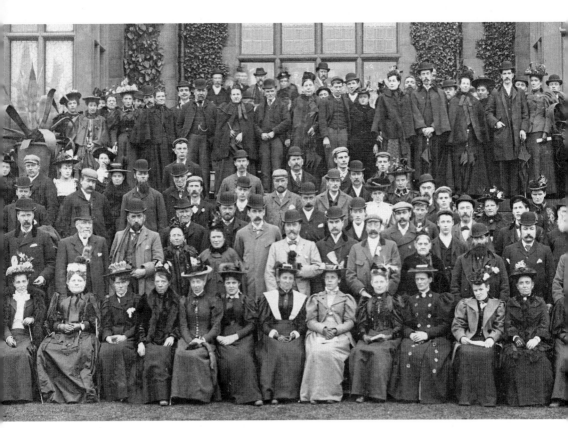

This splendid group photograph was presented to the Gateacre Society in 2005, having been found by chance in mid-Wales. It was taken on 1 October 1896, two days after William Hall Walker's marriage to Miss Sophie Sheridan. The wedding had taken place in Sophie's home village of Frampton, Dorset, but 2,500 guests were invited to Gateacre Grange to celebrate the occasion. The majority were Walker's Brewery employees and their families from Burton, Warrington, Uttoxeter and Liverpool, who arrived on special trains. Others were villagers from Gateacre, many of them being tenants of Walker property. The following day's issue of the *Liverpool Mercury* carried a full report of the event, including the fact that, 'Unable to be personally present on the occasion, Major Walker availed himself of the opportunity afforded by science by addressing the assembly through the medium of the phonograph.' The day's festivities concluded with a firework display in the grounds.

7

WOOLTON HILL

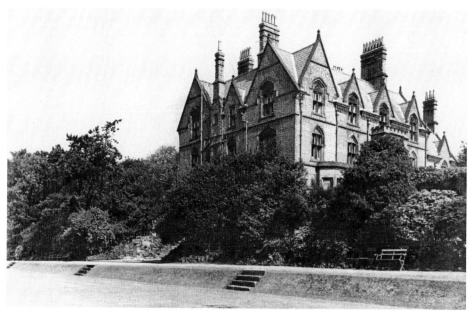

The large Victorian Gothic house Strawberry Field was built around 1867 for George Warren and his American wife. The name was in use before the house was built, for the five-acre field had been a market garden run by William Bennett and his wife Susan. No doubt strawberries were among the fruits grown here for the Liverpool market. Mr Warren was manager of the Liverpool office of the White Diamond shipping line of Boston. When the American Civil War began in 1861 their ships were transferred to the British flag, becoming the Warren Line with headquarters in Liverpool. George Hignet Warren took over the firm after his father's death and in 1881 he, his sisters Mary and Edith, and seven servants were living at Strawberry Field. The house was sold to the Salvation Army in 1934, by the widow of Liverpool merchant Alexander C. Mitchell. It opened as a children's home in 1936. A near neighbour in the 1950s was John Lennon, whose childhood home was at No. 251 Menlove Avenue and whose memories inspired the famous Beatles song *Strawberry Fields Forever*. The old house was demolished around 1970 to make way for a new, purpose-built children's home, which opened in 1973.

The Abbots Lea, Beaconsfield and Lower Lee estates on Woolton Hill were, before 1913, all within the township of Little Woolton and came under the jurisdiction of the Little Woolton Local Board centred in Gateacre village. We have therefore included photographs of these and other areas which were inside the Little Woolton boundary. The mid-nineteenth century was a time of increasing prosperity in Liverpool and the surrounding area. Gentlemen of business, such as ship owners, merchants and cotton brokers were able to have fine country houses built within travelling distance of the city. Typical examples were the houses built along Beaconsfield Road from 1860 onwards. The district was also a convenient and healthy retreat for those whose wealth was derived from the chemical industries of the Mersey valley and Cheshire.

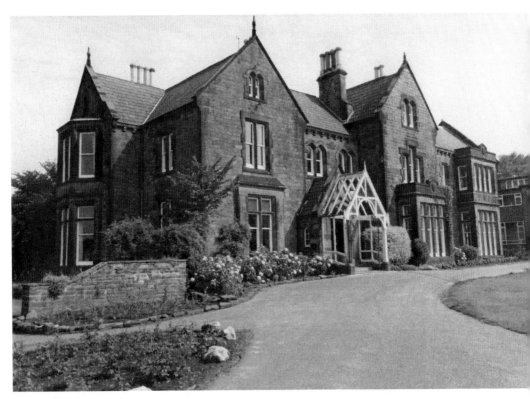

Ship owner John Bushby, who was chairman of the Little Woolton Board 1881–95, built Abbots Lea around 1862. Widnes soap manufacturer William Winwood Gossage was the occupant from 1899 to 1912. After requisition by the War Office the house was bought by Liverpool Corporation in 1948 and is now part of a special school.

Right: Sir Benjamin Sands Johnson (1865–1937) was born in Kirkdale, educated at the Liverpool Institute, and went to work in his father's business (Johnson's dyers and cleaners) at the age of sixteen. He became Mayor of Bootle in 1893, aged only twenty-eight, and was knighted in 1910.

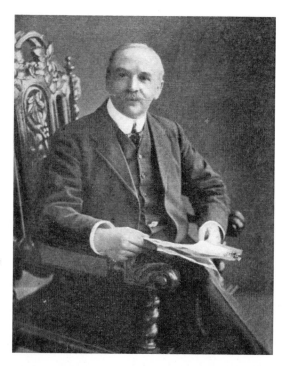

Below: Sir Benjamin Sands Johnson purchased Abbots Lea in 1913. During the First World War he was appointed director general of the Royal Army Clothing Department, and in 1923 he was High Sheriff of Lancashire. In this photograph he is the seated figure with the little white dog, and on the left is his head gardener.

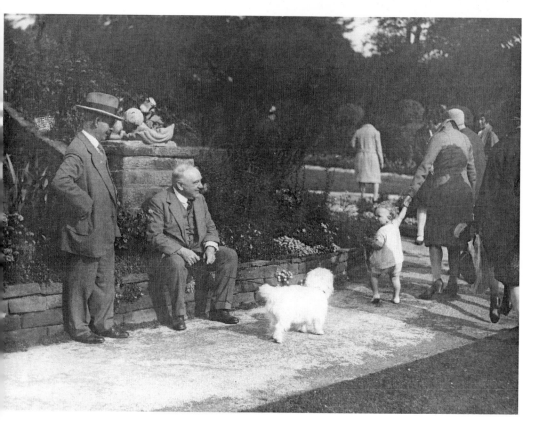

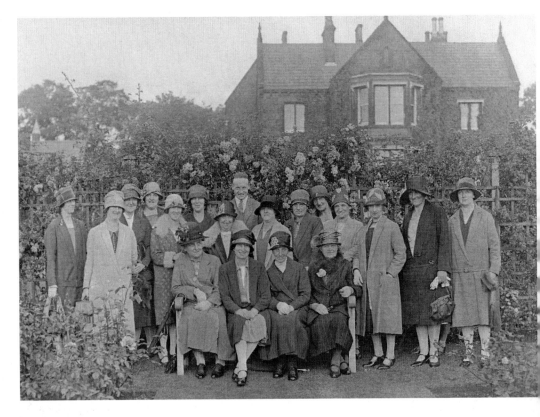

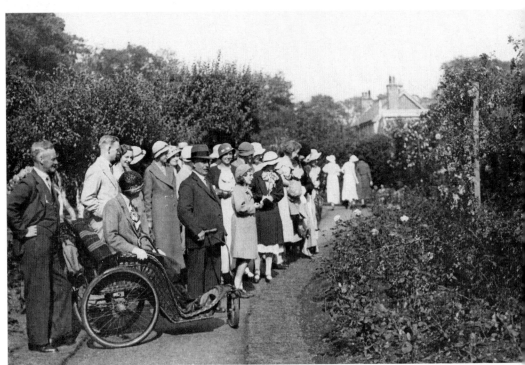

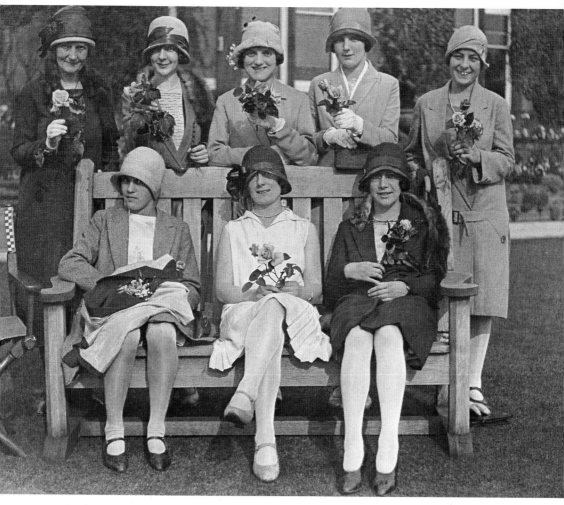

An Abbots Lea garden party group in the 1920s. Short, lightweight summer coats, cloche hats, pale coloured silk or lisle stockings and Louis heeled shoes with a single bar strap were all the fashion.

Opposite above: Garden parties were held in the grounds of Abbots Lea for the mainly female staff of the cleaning firm, and photographs were taken as a record of the day. This group has been assembled amongst the rose beds, with a side view of the house in the background.

Opposite below: Aligned behind the Abbots Lea gardener, this group admire one of his flower beds. One lady is viewing the flowers from a rather elegant wicker bath-chair.

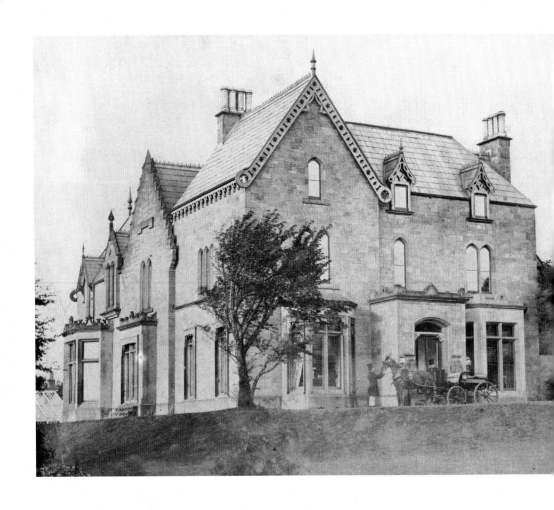

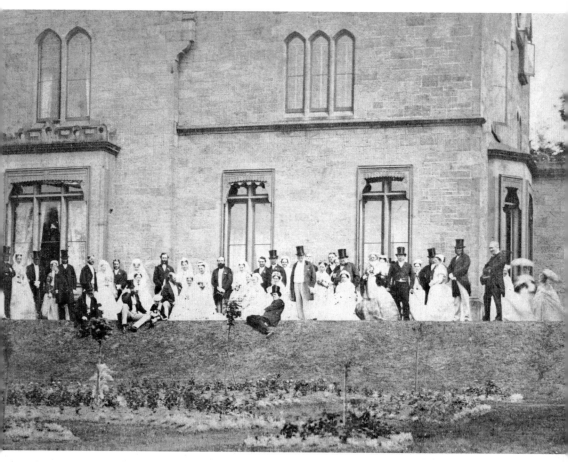

Thomas Carey's daughter Catherine at the age of twenty-one married Chapple Gill, the son of cotton broker Robert Gill of Knotty Cross, Gateacre. The wedding took place on 10 June 1868. It is impossible to tell for certain which of the ladies seated on the Lower Lee terrace might be the bride. Perhaps the central seated figure, hatless and bearded is the bride's father.

Opposite above: The attractive red-sandstone mansion, Lower Lee, featuring a variety of architectural detail, was unfortunately demolished around 1963. It had been built for merchant Thomas Carey around 1861 by the architect Sir James Picton.

Opposite below: Mr Chapple Gill leaving for the office in his pony and trap. In 1880 he was head of the cotton broking firm R. & C. Gill and by 1885 owner and occupier of Lower Lee.

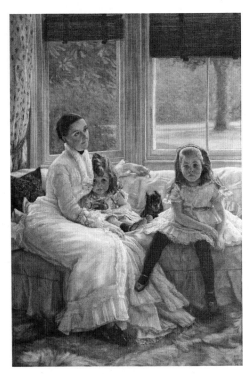

Catherine Smith Gill lived at Lower Lee until her death in 1916. In 1877, the year the Walker Gallery opened, she and two of her children were painted, seated in the window seat of the drawing room, by James Tissot. The picture can be seen at the gallery.

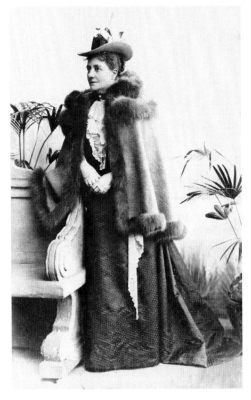

This studio portrait, complete with parlour palms, shows Mrs Catherine Gill attired in a wool cape, lavishly edged with fur, over a brocade dress with lace fichu, the whole topped with a jaunty felt and feathered hat.

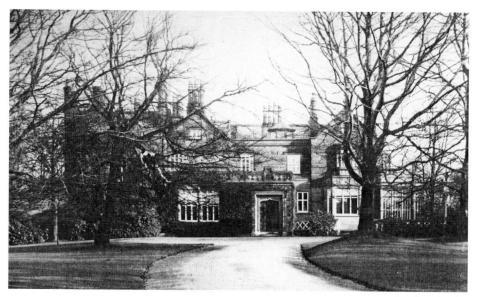

Built in 1833 for Liverpool attorney Ambrose Lace, Beaconsfield stood for 100 years. Owners included; banker Charles Mozley JP, the first Jewish Mayor of Liverpool (1863); Daniel James, a merchant with business interests in America, until 1876 and then his widow Mrs Ruth Lancaster James until 1907. The house and lodges were then sold to Mr P.H. and Mrs Dorothy Hemelryk, who were there until 1928. John Hughes, a builder, bought the estate and demolished the house in 1933. Its site is now occupied by Newcroft and Hillcroft Roads.

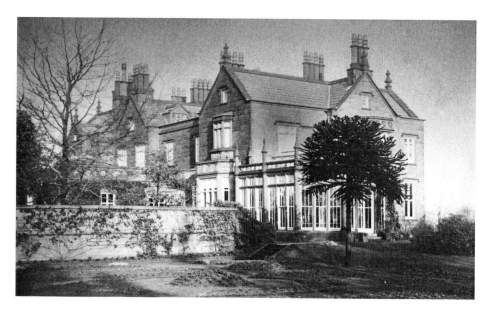

By 1907 the Beaconsfield estate had increased from the original five acres to over twenty acres. The stone country house had canted bays with tall mullioned windows, a plenteous supply of chimneys and the gables carried elaborate finials. Additions were a three-storey tower to the north-west wing and an elegant stone conservatory at the south-west corner.

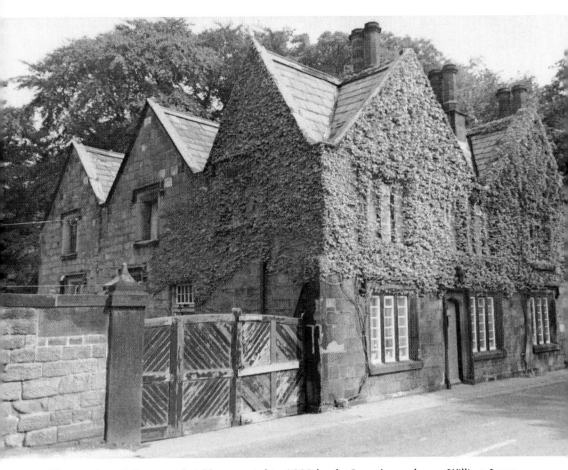

The coachman's house and stable, occupied in 1881 by the James's coachman William Large
and his family, is the only building remaining from the original Beaconsfield estate of 1833.
Rescued from dereliction over twenty years ago, it has again been fully refurbished and extended,
making it a treasured and desirable residence once more.

Opposite: After 1848 the Beaconsfield estate boundary was extended to encompass two
semi-detached dwellings. Fine sandstone gatepiers topped with ornamental lanterns marked the
lodge entrance to the new carriage drive. In 1881 the two houses were occupied by gardeners.

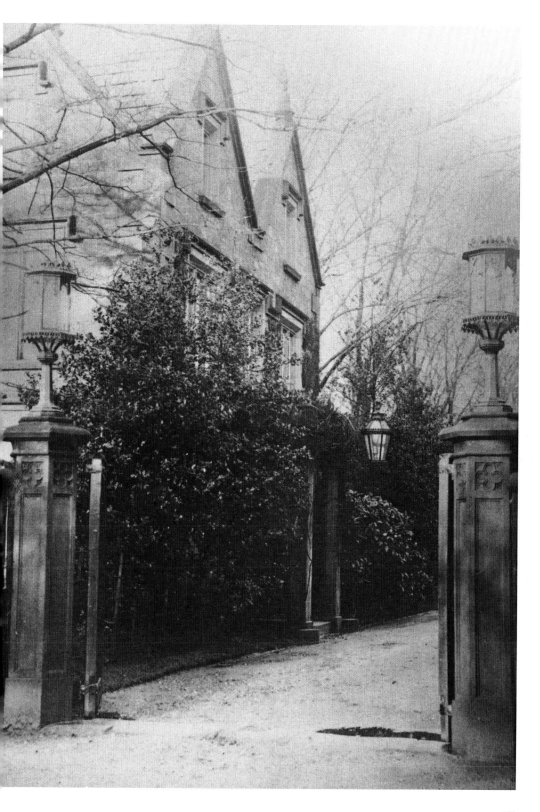

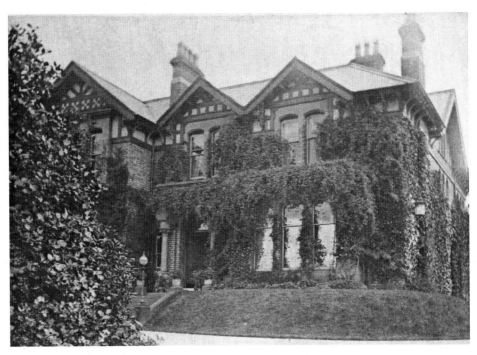

The house originally known as Baycliff stands high on Woolton Hill Road, above what was the old Little Woolton township quarry (where Parkwood Road is now). A service hospital in the Second World War, it was sold to the Church Commissioners in 1948 and is still Bishops Lodge, the residence of the Anglican Bishops of Liverpool.

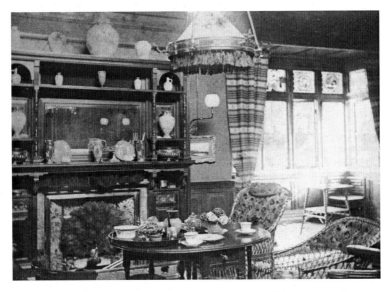

Mr and Mrs J. Thornely and their six children moved from Browside, Gateacre Brow, to Baycliff, Woolton Park around 1875, when the house was about five years old. This is their sitting room, which had a study area on one side close to the large bay window.

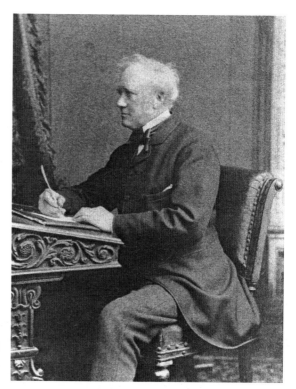

James Thornely was a Liverpool solicitor, who also served as the law clerk to the Little Woolton Local Board. A strong Unitarian, he and his son James Lamport Thornely compiled a history of Gateacre Chapel.

Mrs Laura Thornely was the granddaughter of William Roscoe of Liverpool (1753–1831). Roscoe was a lawyer, poet and art collector; one of the few citizens of Liverpool who fought for the abolition of the slave trade.

The Thornelys bought and extended the next door property, calling it Cliff Cottage in around 1885. As the name suggests it stood perched atop the sheer face of another disused stone quarry, known as The Dell, which was, when part of Sir James and Lady Reynolds' estate, landscaped with flower beds and an ornamental pond.

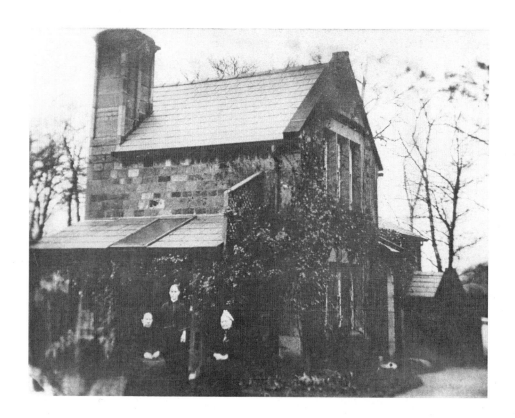

Above: Cliff Cottage was altered and extended for Laura Thornely's mother, Mrs Martha Roscoe, who was still there in the 1890s. Joseph and Jessie Blundell were the occupants (as caretakers of Baycliff) in 1917 and Joseph Penlington (head gardener of Baycliff) lived there from 1921-51.

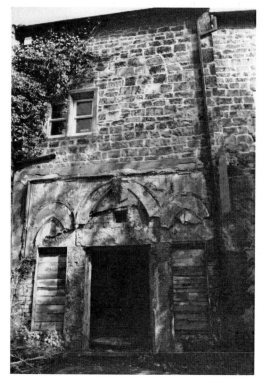

Right: Built into the rock face underneath Cliff Cottage was the summerhouse which had, in the back wall, a central fireplace.

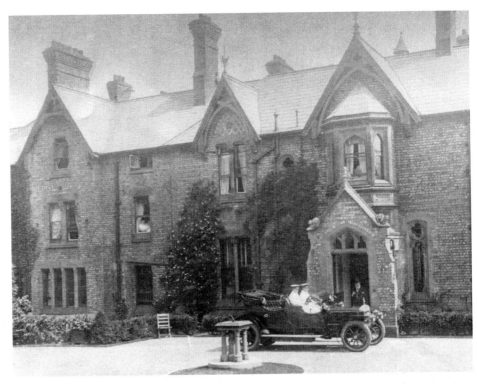

The Priory, which was built around 1870 and demolished in the 1930s, stood in extensive grounds towards the bottom of Woolton Hill Road, where Bower Road is today. The 1881 Census records its occupants as Arthur B. Forwood (described as an 'alderman, magistrate, steam-ship owner and merchant'), his wife Mary, two daughters, three sons and nine servants. There were also two lodges listed – occupied by the coachman and the gardener and their respective families.

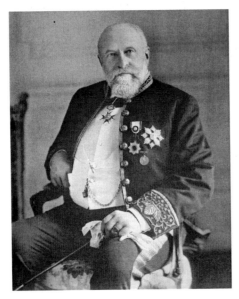

Paul Edward Joseph Hemelryk (1840–1919) lived at The Priory from 1910 until his death nine years later. He and his wife Caroline had twelve children, the eldest of whom, Paul Henry, lived close by at Beaconsfield. Born in Leiden, Holland, P.E.J. Hemelryk moved to Liverpool in 1862 and traded as a cotton broker, a partner in the firm of Hornby, Hemelryk & Co. He was a member and supporter of several Roman Catholic charitable organisations, spoke five languages, and was at one time the Consul for Japan in Liverpool.

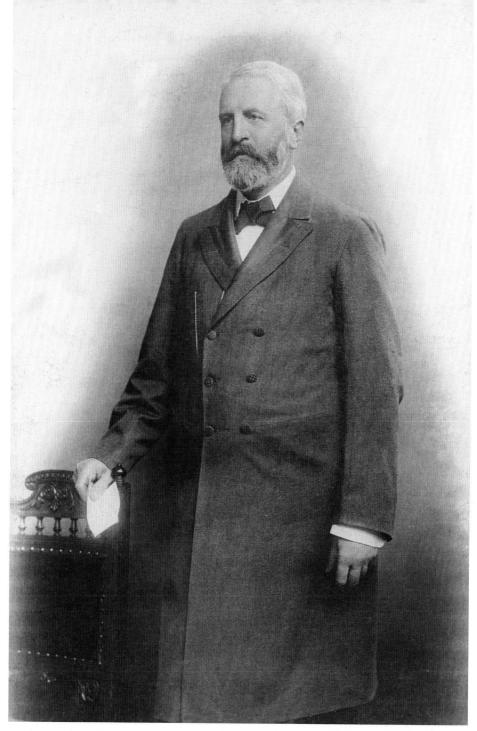

Sir Arthur Bower Forwood (1836–1898) was a Liverpool-born merchant and ship owner. He was also a prominent Conservative politician: Mayor of Liverpool in 1877–8, MP for Ormskirk 1885–98, and a Privy Councillor, having served as Parliamentary and Financial Secretary to the Admiralty 1886–92 under Lord Salisbury. In 1895 he was made a baronet: the 1st Baronet Forwood of The Priory, Gateacre. Today he is commemorated by a statue in St John's Gardens, Liverpool – as well as by the name Bower Road.

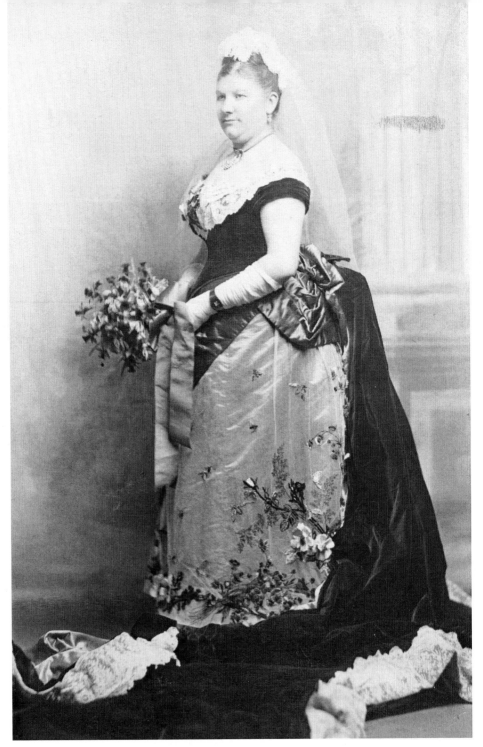

Lady Mary Forwood, wife of Sir A.B. Forwood, was born in West Derby in about 1842. This magnificent formal portrait was given to the Gateacre Society by the present Lady Forwood, who lives in Surrey. The dress of rich dark velvet bears a long, wide train thickly edged with lace, and is fronted with a flower embroidered panel. The bustle, ornamented with thick ruched satin, was very much the fashion in the 1880s.

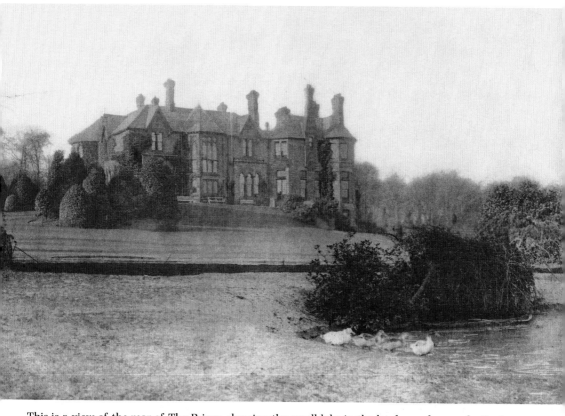

This is a view of the rear of The Priory, showing the small lake in the landscaped grounds. During the period of the Forwoods' residence, the house was the venue for all sorts of social gatherings. We have a record of an 'At Home' held in November 1888 for 600 guests. Among those present were the Earl and Countess of Sefton, Lord and Lady Derby, Sir Andrew and Lady Walker, as well as numerous Liverpool ship owners and their wives, and members of most of the prominent Gateacre families of that era. A decorated marquee was erected in the grounds, and in the evening there was dancing in the drawing room.

When the contents of this book were being finalised, in early 2009, we did not have a photograph of The Priory or of its occupants. Then, by chance, we were contacted by a descendant of the Hemelryks, who sent us (from Australia) the images printed on page 124. Two weeks later we received (from the south of England) the splendid photograph reproduced above, together with those on pages 125 and 126, courtesy of Sir Peter Forwood, the 4th Baronet. How many other pictures of Gateacre buildings or people are still, we wonder, waiting to be discovered?

Other titles published by The History Press

Criminal Liverpool
DANIEL K. LONGMAN

Criminal Liverpool is an entertaining and informative round-up of some of the strangest, most bloodthirsty, despicable and comical crimes that took place in and around Liverpool from the Victorian era up to the mid-twentieth century. Daniel K. Longman's painstaking research has uncovered many cases that have been long forgotten, and sheds new light on local cause célèbres.

978 07509 4749 7

Hanged at Liverpool
STEVE FIELDING

Over the years the high walls of Liverpool's Walton Gaol have contained some of the most infamous criminals from the north of England. The history of execution at Walton began with the hanging of an Oldham nurse in 1887, and over the next seventy years many infamous criminals took the short walk to the gallows here. Fully illustrated with photographs, news cuttings and engravings, *Hanged at Liverpool* will appeal to everyone with an interest in the shadier side of Liverpool's history.

978 0 7509 4731 0

800 Years of Haunted Liverpool
JOHN REPPION

This creepy collection of true-life tales takes the reader on a tour through the streets, cemeteries, alehouses, attics and docks of Liverpool. Containing many tales which have never before been published, it unearths a chilling range of supernatural phenomena, including the Grey Lady of Speke Hall and the truly terrifying tale of 'Spring Heeled Jack', the unidentified apparition who terrorised the citizens of Everton during the 1830s.

978 0 7524 4700 1

Liverpool's Own
CHRISTINE DAWE

This book contains more than a hundred mini-biographies of Liverpool's famous sons and daughters – all of whom are illustrated. A perfect souvenir for visitors to the city, this is also essential reading for Liverpudlians everywhere, and is sure to appeal to those wanting to know more about these people's contributions to the great city we know today.

978 0 7509 5049 7

Visit our website and discover thousands of other History Press books.

www.thehistorypress.co.uk